Film·Video·New Media

AT THE ART INSTITUTE OF CHICAGO: WITH THE DONNA AND HOWARD STONE GIFT

THE ART INSTITUTE OF CHICAGO

YALE UNIVERSITY PRESS, NEW HAVEN AND LONDON

Executive Director of Publications: Susan F. Rossen; Editor of *Museum Studies*: Gregory Nosan; Designer: Jeffrey D. Wonderland; Production: Sarah E. Guernsey and Kate Kotan; Photo Editor: Joseph Mohan; Subscription and Circulation: Bryan D. Miller and Molly Heyen.

This publication was typeset in Stempel Garamond; color separations were made by Professional Graphics, Rockford, Illinois. Printed by Meridian Printing, East Greenwich, Rhode Island.

Distributed by Yale University Press, New Haven and London www.yalebooks.com

This publication is volume 35, number 1 of *Museum Studies*, which is published semiannually by the Art Institute of Chicago Publications Department, 111 South Michigan Avenue, Chicago, Illinois, 60603-6404.

For information on subscriptions and back issues, consult www.artic.edu/aic/books/msbooks or contact (312) 443-3786 or pubsmus@artic.edu.

Ongoing support for *Museum Studies* has been provided by a grant for scholarly catalogues and publications from the Andrew W. Mellon Foundation.

Cover: Pierre Huyghe, *Les Grands Ensembles (The Housing Projects)*, see pp. 68–69.
Frontispiece: Steve McQueen, *Exodus*, see p. 92.
Opposite: Diana Thater, *Delphine*, see pp. 56–57.

This book was produced using paper certified by the Forest Stewardship Council.

ISSN 0069-3235
ISBN 978-0-300-14690-5

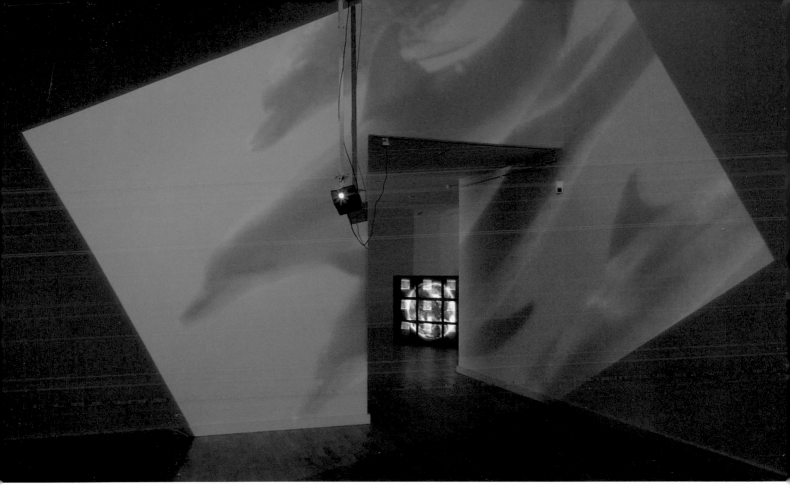

CONTENTS

FOREWORD AND ACKNOWLEDGMENTS

This publication documents for the first time the Art Institute of Chicago's outstanding holdings of media-based work, an increasingly important segment of our distinguished collections of modern and contemporary art. The great majority of the pieces presented here—some of which have been in the museum for decades, others of which are recently acquired—have rarely, if ever, been on display within our walls. Now, with the opening of the new Modern Wing and the inauguration of the Donna and Howard Stone Gallery for Film, Video, and New Media, we very much look forward to taking full advantage of facilities and technologies that will allow us to install them on a regular basis. The collection reflected between these pages is not a stagnant one, and, with this extraordinary foundation in place as a mandate to add strength to strength, we anticipate being able to enhance our holdings with important works in the years to come.

We could not be more pleased and proud to share these artworks with a wide audience through this issue of *Museum Studies*. For making this project possible, I am grateful first and foremost to the authors, almost all of whom are current or former staff members in the Department of Contemporary Art: Kristin Marie Brockman, Departmental Assistant; Lisa Dorin, Assistant Curator; Jenny Gheith, Curatorial Assistant; Eileen Jeng, Research Assistant; Nora Riccio, Collection Manager; and former research assistants Elizabeth Lane, Karsten Lund, and Alison Stone. We also acknowledge the contribution of Assistant Curator of Photography Katherine Bussard. A special note: all authors—myself included—are identified by the initials that follow each catalogue entry.

I would like to offer special thanks to Lisa Dorin, who brings a remarkable passion and expertise to the discipline of film and video studies, for her diligent oversight of all aspects of this undertaking. This publication has been Lisa's project from start to finish, and it has been a labor of love for her to bring greater visibility, increased care, and new scholarship to these works of art. Lisa joins me in thanking Chrissie Iles of the Whitney Museum of American Art, New York, a leader in the field, for her guidance and willingness to share her knowledge and experience. We are also grateful to Amy Beste at the School of the Art Institute of Chicago for three years worth of discussions and invaluable editorial commentary. Our esteemed collaborators Ann Goldstein, Philipp Kaiser, Paul Schimmel, Jeremy Strick, and Ari Weisman of the Museum of Contemporary Art, Los Angeles, worked closely with our curatorial staff to realize the two acquisitions that we share between our museums. We thank them for their excellent partnership and look forward to further shared endeavors. I would also like to acknowledge our colleagues at the School of the Art Institute who worked with us on the gift of the Society for Contemporary Art films from 1973: professors Bruce Jenkins and Dan Eisenberg; Claire Eike and Henrietta Zielinski of the Flaxman Library; and Thomas Hodge and Barbara Scharres at the Gene Siskel Film Center.

James Cuno, President and Eloise W. Martin Director of the Art Institute, has been a generous ally of our collecting and exhibition efforts with contemporary art in general and time-based works in particular. We would not have nearly as impressive an institutional track record—so much of what is featured in this issue has been acquired recently under his tenure—without his leadership and support. Deserving of the greatest praise are conservator Suzanne Schnepp, who has devoted continued, creative attention to the care

and preservation of these works, and Nora Riccio, who has significantly upgraded our archiving and collecting practices in recent years. I am also deeply grateful to all those who helped bring this publication into print: Susan F. Rossen took up my proposal for the project enthusiastically, and Greg Nosan brought his sharp eye and pencil to the text, which benefited enormously from his attention. The production team of Sarah Guernsey and Kate Kotan worked tirelessly to ensure that every image looked as beautiful as possible on the page. Joseph Mohan and Eileen Jeng contributed to this goal immeasurably, tracking down dozens of film and video stills, installation views, and the rights to reproduce them, working closely with the artists and their galleries and representatives. In many cases, however, we produced our own images with the help of Gregory Harris, who created stills from film prints; of Bill Foster, Tommy Riley, and Jason Stec, who made video still captures; and of Nicholas Barron and Robert Hashimoto who, with Caroline Nutley, set up, photographed, and processed installation images. The smart, sensitive design was the work of Jeff Wonderland.

The former and current members of Society for Contemporary Art deserve great credit for their ongoing support of our department and for the many film and video works they have purchased through their annual acquisition process. Our sincere appreciation also goes to all of the individual collectors and donors in Chicago who have contributed to our media collection and whose names can be seen in the credit lines throughout this volume: Barbara Ruben, Claire Prussian, Dorie Sternberg, Dirk Denison, Stephanie Skestos Gabriele, Martin Friedman and Peggy Casey-Friedman, Jim Cahn and Jeremy Collatz, Brad Smith and Don Davis, and Robert and Marlene Baumgarten. Finally, it is with particular gratitude, respect, and affection that I acknowledge the munificence of Donna and Howard Stone for the extraordinary gift of fifteen major works of video, the funding for many more, and the new gallery dedicated to the presentation of electronic media. Their transformative generosity has changed our museum for the better. In particular, their enlightened support of new media has done for our holdings in film and video what the gift of Lannan Foundation did for our collection of contemporary paintings and sculpture over ten years ago—that is, strengthened and enriched our dedicated efforts to bring together the most comprehensive, diverse, and adventurous collections of recent art to be found in any general museum anywhere in the world.

JAMES RONDEAU
Curator and Frances and Thomas Dittmer Chair,
Department of Contemporary Art

"HERE TO STAY": COLLECTING FILM, VIDEO, AND NEW MEDIA AT THE ART INSTITUTE OF CHICAGO

LISA DORIN, ASSISTANT CURATOR OF CONTEMPORARY ART

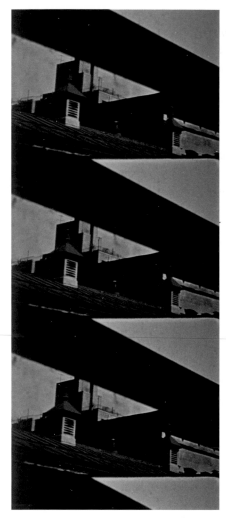

Figure 1. Stan Brakhage (American, 1933–2003). *Wonder Ring*, 1955 (pp. 12–13).

Published to mark the May 2009 opening of the Renzo Piano–designed Modern Wing—and, with that, the state-of-the-art Donna and Howard Stone Gallery for Film, Video, and New Media—this issue of *Museum Studies* explores the Art Institute's significant holdings in electronic media, charting the history of their inclusion in the museum's permanent collection. Organized chronologically by acquisition date, the publication surveys holdings that now contain over eighty works and comprise films; single and multichannel projective and monitor-based videos; slide installations; and sound works. While they are not intended as a comprehensive history of film and video, the catalogue entries—which explore each of the works mentioned in this essay and many others besides—reveal much about the shape electronic media have taken over the last half-century.

Whereas some museums have exhibited and collected time-based media since artists began working with them, most encyclopedic institutions have not made this a priority, or have only begun to do so in recent years.[1] The first moving-image work to enter the Art Institute's collection, George Segal's *The Truck*—a sculptural installation with a film component—was acquired in 1966, the same year it was created. It is fitting that the Art Institute's curators would have turned an eye to art film and video early on, as Chicago has long enjoyed a reputation as a beacon for electronic-media artists; this is due in large part to the strengths of the School of the Art Institute of Chicago and the University of Illinois-Chicago, which have been the home of both innovative instructors and cutting-edge facilities designed especially for artistic experimentation.[2] Founded in 1972, the school's Art and Technology Department was the first of its kind. The Film Center (now the Gene Siskel Film Center) and Video Data Bank, both also established in 1972, have long been vital resources for artists and institutions alike.[3]

The museum's earliest film and video acquisitions were due in no small measure to the combined vision of A. James Speyer, Curator of Twentieth-Century Painting and Sculpture; Assistant Curator Anne Rorimer; and the Society for Contemporary Art, an independent group of collectors, founded in 1940, whose primary function has been to purchase a work of art for the Department of Twentieth-Century Painting and Sculpture (now the Department of Contemporary Art) on an annual basis.[4] After Segal's *The Truck*, the next film acquisition occurred in 1973, when the society—along with Speyer, Rorimer, and Camille Cook, the founding director of the Film Center—organized *Contemporary Film Art*, an exhibition at the museum of twenty 16mm films, all but two of which were subsequently purchased.[5] The society was primarily interested in films made by painters and sculptors, works such as Bruce Nauman's *Dance or Exercise on the Perimeter of a Square* and Richard's Serra's *Hand Catching Lead*. Cook, an expert in experimental film, broadened the selection to include *Wonder Ring* by Stan Brakhage (see fig. 1), Michael Snow's *Wavelength*, and others. Attempting to lend authority to a misunderstood and underappreciated art form, the introduction to the accompanying exhibition list offered the following vote of confidence: "The Society for Contemporary Art

recognizes the artists' migration to the film medium, and this 1973 annual exhibition clearly affirms that 'film is art.' The film form is not a bizarre aberration—it is here to stay as an application of technology to a creative end."[6] These reflections may sound quaint today, but at the time it showed particular foresight to bring together, in a museum context, films made by artists on one hand and filmmakers on the other; even now, it is rare to see them combined.

One work considered for inclusion in *Contemporary Film Art*, but not selected, was Bruce Nauman's *Art Make-Up, Nos. 1–4*. Instead, it was purchased by the museum and included in Rorimer's *Idea and Image in Recent Art*, a 1974 exhibition that investigated Marcel Duchamp's far-reaching influence on contemporary art. Also included were reels from William Wegman's video compilation *Selected Works* and Vito Acconci's video *Face Off*. Both were lent by the Castelli-Sonnabend Gallery, New York, the preeminent source for artists' films and videos at that time.

Compared to the boom that occurred in the following decade, most museums made relatively few film and video acquisitions in the 1980s, and the Art Institute was no exception.[7] In 1983, however, the Society for Contemporary Art's annual gift made possible the accession of Bob Snyder's *Lines of Force* and *Trim Subdivisions* and Bill Viola's *Reflecting Pool*, a compilation tape of five videos. Snyder, who has made work that uses a computer to process both original and appropriated footage, has been an innovator in the synthesis of sonic and visual elements through the use of new technologies. Viola, known for lyrical, mystical works, is arguably among those most responsible for the widespread popularization of video art. *Reflecting Pool* and other early single-channel tapes presage his later monumental installations. Snyder and Viola's creations differ vastly in their content and conceptual concerns, yet the society's voting members recognized certain formal affinities—for instance, the use of experimental video techniques and the sculptural application of sound— that made this joint gift both insightful and appropriate.

Due in part to innovations in digital video technologies and increasingly accessible editing resources, the 1990s saw an explosion in the creation and exhibition of video work. The Art Institute's acquisitions during this period grew significantly, a change that can be attributed to the Society for Contemporary Art, two major foundation gifts, and departmental efforts that were sustained by funds from local supporters. In 1992, the society acquired *Family of Robot: Baby* by Nam June Paik, an artist often referred to as the "George Washington of video art." The following year, Viola's important installation *Reasons for Knocking at an Empty House* entered the collection, followed in 1997 by three seminal pieces that came as part of a major gift from Lannan Foundation: Bruce Nauman's groundbreaking *Clown Torture* (see fig. 2); *Good Boy Bad Boy*, also by Nauman; and Gary Hill's *Inasmuch As It Is Always Already Taking Place*.[8] In 1998, the Peter Norton Family Foundation sponsored curator Okwui Enwezor's acquisition of four major video animation works by William Kentridge. A year later, the museum commissioned and purchased Iñigo Manglano-Ovalle's *Sonombulo II*, the first sound environment in our collection.

The years since 2000 have brought unprecedented growth to the Art Institute's film and video holdings as a result of a major departmental initiative headed by James Rondeau, Curator and Frances and Thomas Dittmer Chair. Recognizing that many contemporary artists were making their most ambitious statements in the form of video—particularly video installation—and that these works were exerting a major impact on the practice of art internationally, Rondeau pursued a new, more systematic and intensive approach to collecting them. Essential to this undertaking

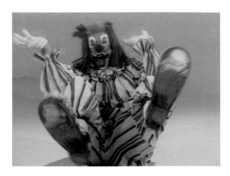

Figure 2. Bruce Nauman (American, born 1941). *Clown Torture*, 1987 (pp. 18-21).

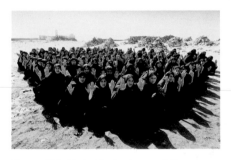

Figure 3. Shirin Neshat (Iranian, born 1957). *Rapture*, 1999 (pp. 80–81).

has been the support of private donors—particularly Chicago-based collectors Donna and Howard Stone. In 2000, the Stones established a fund specifically for the purchase of film, video, and new media works, and in 2007 made an extraordinary donation of fifteen key video installations by some of the most prominent artists of the last decade. No other single gift has affected the shape of the media collection in the way the Stones' has. Although the couple actively acquire artworks of all kinds, they possess a singular vision for their video collection: to encompass many of the major figures and moments in the recent history of the medium. Importantly, they have collected with institutional ambitions, rarely, if ever, buying works that could be presented in a domestic setting. Major touchstones include Isaac Julien's three-channel *The Long Road to Mazatlán*, shown in rear projection; *the moment*, a monumental eleven-channel installation by Doug Aitken; and *Rapture* (see fig. 3), a two-channel installation by Shirin Neshat.

As is the case with its collection of works in other media, the Department of Contemporary Art has sought to build upon existing strengths. The museum has acquired, for example, five works by leading British artist Steve McQueen—more than any other single institution—from the early, modest film *Exodus* to the recent and extremely ambitious *Gravesend*.[9] Moreover, his *Girls, Tricky* will be the inaugural presentation in the Donna and Howard Stone Gallery for Film, Video, and New Media. By following the careers of artists such as McQueen, Doug Aitken, and Joshua Mosley over time and building up a concentration of their work, we are able to understand their production more thoroughly, better assessing the magnitude of their contribution to contemporary film and video practice.

Conversely, the department has also set about addressing notable gaps in its holdings by accessioning singular works such as Nan Goldin's seminal multimedia slide installation *The Ballad of Sexual Dependency*, which represents the first joint acquisition between the departments of Contemporary Art and Photography. The museum has also purchased a number of early experiments that emerged from film and video's productive intersection with Conceptual and performance art in the 1970s, including Gordon Matta-Clark's 16mm film *Splitting* and videotapes such as John Baldessari's *Baldessari Sings LeWitt*. Also acquired was Dara Birnbaum's *Technology/Transformation: Wonder Woman*, a brilliant example of 1970s work that appropriates recognizable imagery from mainstream television, using it in the service of media and gender critique. Another important arrival is the LED installation *Blue Tilt*, a major work by renowned artist Jenny Holzer. Incorporating texts from five of her most iconic series from the 1970s and 1980s, *Blue Tilt* situates Holzer alongside contemporaries such as Barbara Kruger, Sherrie Levine, and Cindy Sherman, who were already represented in the museum's holdings.

Not surprisingly, the Society for Contemporary Art continues to be a strong force behind the acquisition of electronic media. In addition to the group's official gifts, among them films by Aitken and Tacita Dean, there are quite a few examples of works that have been featured in the annual exhibition and not acquired by the society—including those by A K Dolven, David Hammons, Sharon Lockhart, and Salla Tykkä—that were later purchased by the Department of Contemporary Art with the support of individual society members and other donors.

Other major acquisitions that demonstrate a rich range of media include Diana Thater's six-channel video installation *Delphine,* purchased with the Stone New Media Fund in 2005; Rodney Graham's exquisite 35mm film installation *Torqued Chandelier Release,* bought with major acquisition funds; and Zarina Bhimji's deeply moving single-channel video *Out of Blue* (see fig. 4), given by Chicago

Figure 4. Zarina Bhimji (Ugandan, born 1964). *Out of Blue*, 2002 (pp. 44–45).

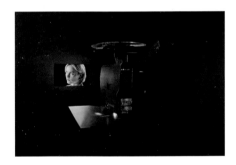

Figure 5. Elad Lassry (Israeli, born 1977). *Zebra and Woman*, 2007 (pp. 104–05).

and Los Angeles– based collector Barbara Ruben. Eija-Liisa Ahtila's *Talo (The House)* and *Questions*, a fifteen-channel slide installation by Fischli & Weiss, were purchased as the first two of three joint acquisitions with the Los Angeles Museum of Contemporary Art. Originated by former Art Institute curator Jeremy Strick as he left to assume the directorship of LAMOCA, this collaboration has involved the efforts of James Rondeau in Chicago and curators Ann Goldstein and Paul Schimmel in Los Angeles.

An encyclopedic museum such as the Art Institute has the rare ability to integrate the contemporary with the historical across all media and geographies, encouraging connections among vastly divergent holdings. Nevertheless, it remains easy to divide our collections along medium-specific lines. This is due in part to the nature of electronic works, which require specialized equipment and technical know-how both in their creation and their display. Museums, used to handling rare and unique objects, are often ill equipped to deal with technology-based works that, in essence, cease to exist when the power is shut off and require expensive equipment that must be stored and maintained.[10] At this moment, film and video are being eclipsed by newer digital media as the problem children of museum collections, and there is still much to be done if they are to be integrated fully into collecting and conservation programs. While the challenges are considerable, as long as artists are creating great works that rely on these technologies, it is the museum's responsibility to showcase and preserve them.

In recent years, the Art Institute has attempted to rise to this task both through its acquisitions program and its conservators' efforts to develop and update practices for newer media. While the museum has a successful track record in the preservation of light-sensitive media—in 1982, it was the first fine-art institution to implement cold storage for photographic prints and negatives—it has also supported the work of Conservator of Objects Suzanne Schnepp, who has undertaken a number of important assessments and treatments on works such as Gary Hill's *Inasmuch As It Is Always Already Taking Place*, Nam June Paik's *Family of Robot: Baby*, and, most notably, Bruce Nauman's *Art Make-Up*.[11]

As the Modern Wing opens and we look to the future of the collection, the Department of Contemporary Art has continued to seek out emerging artists who represent diverse approaches to electronic media. Among these is the Israeli-born, Los Angeles–based Elad Lassry, whose Super 16mm films *Untitled (Agon)* and *Zebra and Woman* (see fig. 5) are the latest additions to the holdings. Clinging to a medium that is arguably within decades of its demise, Lassry is one of a number of younger artists who are returning to an intimate, analog film experience.[12] When watching this work, viewers can see scratches and lint in the picture frame, notice traces of the leader appearing between each loop, and hear the whirring and clicking of the projector. On the other end of the spectrum, however, the museum is also pursuing work from the cutting edge of new technologies. The Donna and Howard Stone Gallery for Film, Video, and New Media has been designed to generously accommodate media that the museum has yet to acquire, including software-based, interactive media, Web-enabled systems, and virtual-experience platforms, allowing for the utmost flexibility of configuration. This issue of *Museum Studies* represents the history, thus far, of technology-based media in the collection of the Art Institute—a history that has perhaps been unknown to many, but that, thanks to the scholarship in these pages and the opening of the Modern Wing, will soon be familiar to more of our audiences than ever before.

George Segal

American, 1924–2000

The Truck

1966

Metal, plaster, glass, wood, plastic, 16mm
color film, silent, transferred to digital video
(projection); 167.6 x 558.8 x 152.4 cm
(66 x 220 x 60 in.)

Mr. and Mrs. Frank G. Logan Purchase Prize
Fund, 1966.336

In the 1960s, when the Abstract Expressionist and Pop Art movements were transforming artists' working methods, George Segal explored the long-established genre of figurative sculpture. He created life-size human figures using cloth strips dipped in wet plaster and displayed the rough, unpainted casts as his finished product. Segal often placed his sculptural forms within a larger tableau of commercially made objects in order to create active, eerily inhabited spaces.

Purchased in 1966, *The Truck* was the Art Institute's first acquisition to incorporate a moving-image element. The artist combined the front of a red Ford F-Series pickup; one of his signature cast-plaster figures as the driver; and the film *Highway at Night* (projected on the truck's windshield, in a continuous loop) to create what is now commonly referred to as an environmental sculpture. While today's audiences for contemporary art are used to having disparate visual elements presented to them in this way, Segal's early work was truly groundbreaking.

The same year *The Truck* was acquired, it won first prize in the museum's Sixty-Eighth American Exhibition. This display, curator A. James Speyer explained in the catalogue, "shows the work of twenty artists, each with a kind of complete, individual exhibit rather than a single, specific painting or sculpture. . . . All these exhibits share a physical insistence and vital presence which assumes environmental stature."[1] An article on the show in *Time* captures both the novelty of *The Truck* in 1966 and something of what it is like to experience it even now:

> The runaway hit of the show was easily Segal's creation, *The Truck*. It consisted of the actual cab of a red panel truck that Segal had found in a junkyard. Inside, the odometer read 85,723, the generator and oil-pressure gauges glowed red in the dashboard. In the driver's seat was an alert, life-size white plaster driver, both hands on the wheel, right foot hovering over the accelerator. As viewers looked over his shoulders at the windshield, they shared a cinematic ride through city streets, as lights, cars, and bright neon signs whizzed by.

> To bring off the joy ride, Segal had rigged a small film projector and mirror arrangement to the right of the cab, which beamed the movie onto the truck's frosted windshield. Watching it, one housewife confided: "That's the way my husband drives..." Juror Martin Friedman, director of Minneapolis' Walker Art Center, put it another way: "I found it very moving. Actually . . . by treating the man almost as a ghost, as a calcified figure, Segal presents you with reality, then questions the existence of reality.[2]

One of Segal's most important early works, *The Truck* helped to change sculpture by encompassing its viewers—allowing them to share an experience over a period of time—and by blurring the once-steadfast boundaries between life and art.

N.R.

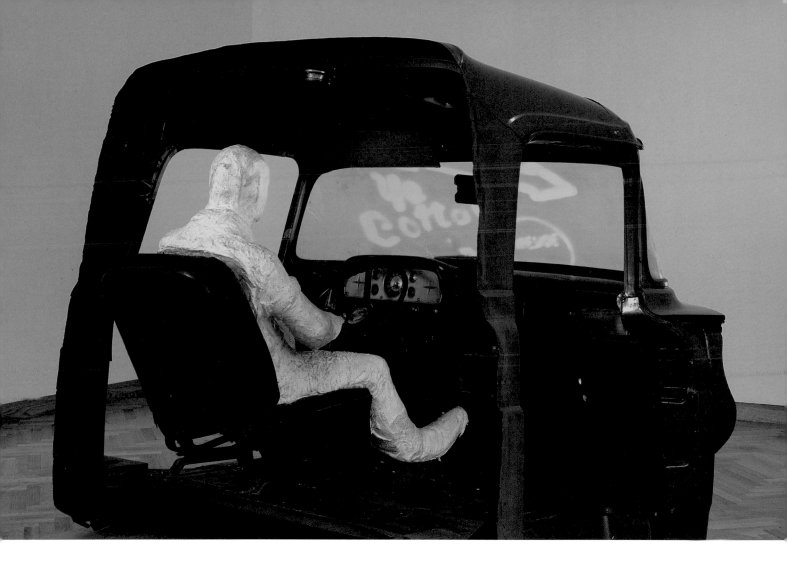

Stan Brakhage

American, 1933–2003

Wonder Ring

1955

16mm color film, silent; 4 min.

Gift of Society for Contemporary Art,
Obj. 184158

Prelude to Dog Star Man

1961

16mm color film, silent; 25 min.

Gift of Society for Contemporary Art,
Obj. 184157

Joseph Cornell

American, 1903–1972

The End is the Beginning

1955

Super 8 color film, sound, transferred to
16mm film; 5 min.

Gift of Society for Contemporary Art,
Obj. 184165

Robert Breer

American, born 1926

Man and His Dog Out for Air

1957

16mm black-and-white film, sound;
3 min.

Gift of Society for Contemporary Art,
Obj. 184159

In spring 1973, the Society for Contemporary Art, in conjunction with the newly formed Film Center at the School of the Art Institute of Chicago, hosted *Contemporary Film Art*, a landmark exhibition featuring twenty films by seventeen artists. The mission of the society, an independent group affiliated with the Art Institute, is to promote a better understanding and appreciation of the art of our time. In this instance, it achieved this end by boldly affirming, "Film is art."[1] *Contemporary Film Art* showcased works by noted filmmakers alongside those of painters and sculptors who looked to film as an extension of their experimental ideas and innovations. In their review in the *Chicago Tribune*, Jane Allan and Derek Guthrie claimed, "It wasn't that they were all great films. In fact, they ranged in quality from very good to downright awful. But as a group, they were lively and they were *about* something or perhaps, reaching for something beyond the ability to fill up a few yards of space or canvas or screen with nicely finished saleable art."[2]

The foresight shown by the society and by Camille Cook, then director of the Film Center, has proved remarkable within the contexts of both the Art Institute's holdings of contemporary art and the larger history of experimental film.[3] The Society for Contemporary Art films include the earliest explorations in the medium by artists such as Robert Morris, Bruce Nauman, Ed Ruscha, and Richard Serra, resonating with their other works in the permanent collection and providing a rich sense of each artist's particular oeuvre. Placed alongside the efforts of noted filmmakers like Jordan Belson, Stan Brakhage, Bruce Conner, and Michael Snow, they reflect the artistic climate of the mid-1950s to early 1970s; this was one defined by fluidity, one in which artists frequently moved between different media, creating a web of dialogue and influence.[4]

The earliest film in the collection is Brakhage's *Wonder Ring* (opposite, at top). Considered one of the most important avant-garde filmmakers, Brakhage, according to filmmaker and curator Brian Frye, "single-handedly transformed the schism separating the avant-garde from classical filmmaking into a chasm."[5] Tellingly, a number of artists in this selection of films looked to Brakhage's earliest works as a source of creative inspiration and insight. Shortly after moving to New York, Brakhage met the artist Joseph Cornell, who commissioned him to film the soon-to-be-dismantled Third Avenue El. Shooting for the first time without actors or a plot, Brakhage instead turned to the expressive qualities of the medium itself. The result was a film with no story, no protagonist, no linear narrative other than the train's endless voyage around the track.[6]

Bruce Conner's first film, *A Movie* (opposite, at bottom), is a tour-de-force of editing, a deluge of images composed entirely of found footage from B-movies, newsreels, novelty shorts, and other sources. Each clip lasts only a few seconds, as the viewer desperately tries to hold at least one image in his or her memory, even though they are impossible to fully absorb. No matter how many times one sees *A Movie*, different scenes leap out, making it appear to be a different film. As Conner recalled, "Every time one of my films is shown, it's a unique event, and it alters my consciousness as well as the rest of the audience's."[7]

As a young artist in New York, Richard Serra was introduced to experimental film through works by luminaries in the field, including Brakhage, Conner, Snow, and Yvonne

Bruce Conner

American, 1933–2008

A Movie

1958

16mm black-and-white film, sound; 12 min.

Gift of Society for Contemporary Art, Obj. 184164

Cosmic Ray

1961

16mm black-and-white film, sound; 4:30 min.

Gift of Society for Contemporary Art, Obj. 184163

Stan VanDerBeek

American, 1927–1984

Science Friction

1959

16mm color film, sound; 9 min.

Gift of Society for Contemporary Art, Obj. 184177

Kenneth Anger

American, born 1927

Kustom Kar Kommandos

1965

16mm color film, sound; 3:30 min.

Gift of Society for Contemporary Art, Obj. 184148

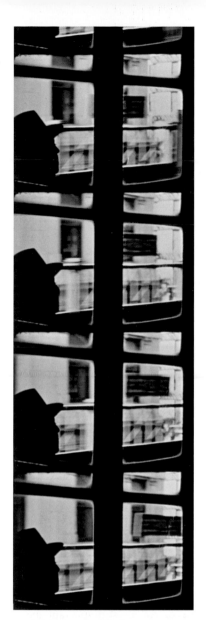

Robert Nelson

American, born 1930

Oh Dem Watermelons

1965

16mm color film, sound; 12 min.

Gift of Society for Contemporary Art,
Obj. 184170

Michael Snow

Canadian, born 1929

Wavelength

1966–67

16mm color film, sound; 45 min.

Gift of Society for Contemporary Art,
Obj. 184176

Richard Serra

American, born 1939

Hand Catching Lead

1968

16mm black-and-white film, silent;
3:30 min.

Gift of Society for Contemporary Art,
Obj. 184173

Hands Scraping

1968

16mm black-and-white film, silent;
3:30 min.

Gift of Society for Contemporary Art,
Obj. 184174

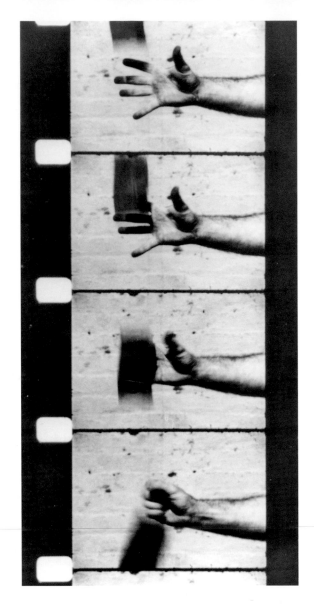

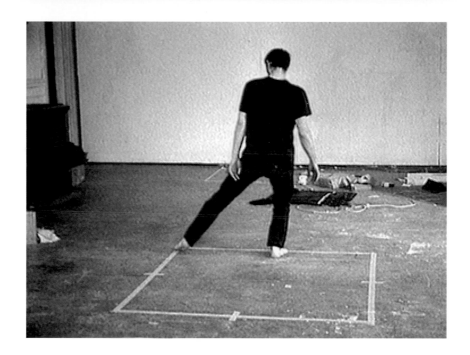

Bruce Nauman

America, born 1941

*Dance or Exercise on
the Perimeter of a Square
(Square Dance)*
1968

16mm black-and-white film, sound,
11 min.

Gift of Society for Contemporary Art,
Obj. 184168

Will Hindle

American, 1929–1987

Billabong
1968

16mm color film, sound; 9 min.

Gift of Society for Contemporary Art,
Obj. 184166

Jordan Belson

American, born 1926

World
1970

16mm color film, sound; 6 min.

Gift of Society for Contemporary Art,
Obj. 184156

Rainer.[8] In the late 1960s, his sculptural work was concerned with cutting, propping, and stacking material, primarily lead, to create structures supported only by their own weight. Serra translated this concept to film in *Hand Catching Lead* (opposite, at top) and *Hands Scraping*. The former shows a close-up of the artist's hand as he attempts to grasp, and frequently misses, lumps of lead as they drop from above. *Hands Scraping*, made in collaboration with composer Philip Glass, depicts Serra trying to remove lead from his studio floor. Both films are playful examinations of an artist's relationship to his materials, yet each suggests a sense of futility about the creative process.

A few years earlier, Serra had struck up a friendship with Michael Snow, who was shooting *Wavelength* (opposite, at bottom). This incredibly influential work, which documents the continuous zoom of a fixed camera within an eighty-foot urban loft, is a key example of a "structural film," a term coined in 1979 by avant-garde film historian P. Adams Sitney to describe works characterized by a pared down, often predetermined practice. In *Wavelength*, the camera is pointed toward an opposing wall that is lined with windows looking out onto the street below. Its zoom takes forty-five minutes to traverse the space from its widest field to its smallest, ending on a lone photograph of waves. The fixed perspective is enhanced by the introduction of colored filters, changes in film stock, and alternating positive and negative processing; it is disrupted, however, by four human events, including a man's apparent death. The soundtrack consists of a sine wave from the lowest to the highest register, overlaid with street sounds, a ringing telephone, speech, and music.

Like Snow's films, Bruce Nauman's works of the late 1960s take as their concept the process of creating art. Yet in his early films, Nauman used his own body as a material.[9] For example, in *Dance or Exercise on the Perimeter of a Square (Square Dance)* (above), he outlines a square on his studio floor with masking tape, marking each side at its halfway point. Beginning at one corner, he methodically moves around the perimeter of the square to the sound of a metronome, sometimes facing into its interior, sometimes out. Each pace is the equivalent of half the length of a side of the taped square. *Dance or Exercise* is among several significant film and video works by Nauman in the Art Institute's collection, which also contains works in other media including the bronze sculpture *Second Poem Piece* (1969), the installation *Diamond Africa with Chair Tuned, D.E.A.D.* (1981), and the monumental neon *Human Nature/Life Death* (1983).

Robert Morris

American, born 1931

Neo Classic

1971

16mm black-and-white film, silent;
15:30 min.
Gift of Society for Contemporary Art,
Obj. 184167

Ed Ruscha

American, born 1937

Premium

1971

16mm color film, sound; 30 min.
Gift of Society for Contemporary Art,
Obj. 184171

Albert Maysles

American, born 1926

David Maysles

American, 1931–1987

Ellen Hovde

American, born 1925

Christo's Valley Curtain

1973

16mm color film, sound; 28 min.
Gift of Society for Contemporary Art,
Obj. 184162

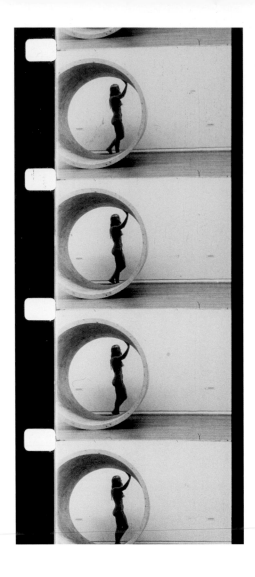

While at first Robert Morris's *Neo Classic* and Ed Ruscha's *Premium* seem far removed from each artist's usual practice, they both represent a playful, tongue-in-cheek use of film. Most known for his Minimalist sculptures, Morris created *Neo Classic* (above) a mere forty-eight hours before the opening of an exhibition at the Tate Gallery, London. The piece shows a naked model wandering through the gallery space while interacting with Morris's artwork. According to the Tate, "The calm, meditative behavior of the model suggests that Morris had no idea that the public would respond to his sculptures so exuberantly."[10] Ruscha's film features his friends Larry Bell, Leon Bing, Rudi Gernreich, and Tommy Smothers, and is based on "How to Derive the Maximum Pleasure from Crackers" (1964), a comic short story by his lifelong friend Mason Williams that he made into the artist's book *Crackers* (1969). *Premium* (opposite) exists as a quirky document of the changing sexual and class sensibilities of southern California in the 1970s. It illustrates precisely Williams's text, which offers a set of absurd instructions that encourage the protagonist to find a beautiful, "hard to get" woman; rent two hotel rooms on the same day, one in a "skid row flop house" and the other in the "finest hotel in town"; purchase a host of fresh vegetables; and build a salad in the bed of the cheap motel. The woman is then brought to the room, where she is coaxed into bed with the salad and covered with dressing, at which point the protagonist runs out of the motel, drives to the nearest store to purchase a box of cheap saltine crackers, and retires to the bed in the expensive hotel

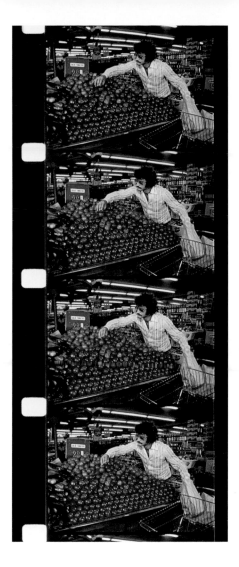

to nibble the crackers and derive "maximum enjoyment from them."[11] At least one artist, the noted conceptual provocateur Jonathan Monk, has looked to this work as a point of departure, as evidenced in *Chinese Crackers* (2006), his own reinterpretation of *Premium* that stars Liu Wei and other Chinese artists.

In 1973—an early date for a museum to be acquiring film—the Society for Contemporary Art, along with Cook and curators A. James Speyer and Anne Rorimer, recognized the medium's relevance in an encyclopedic setting such as the Art Institute's. Filmmakers traditionally house their works in film archives, yet museums can provide a broader context in which they might be understood—not only alongside other films, but also, importantly, in relation to works in other media. To this end, the Department of Contemporary Art is in the process of reconstituting and accessioning the collection of all eighteen films, either by preserving existing prints, purchasing new ones, and, whenever possible, creating new internegatives along with archival and exhibition copies. The goal is to safeguard the objects associated with this remarkable moment in the museum's history and celebrate the visionary efforts of those who paved the way for our continued commitment to collecting cutting-edge art in all media.

E.L.

Bruce Nauman

American, born 1941

Art Make-Up, Nos. 1–4
1967–68

Four 16mm color films, silent, shown simultaneously: *Art Make-Up, No. 1: White*, 1967; *Art Make-Up, No. 2: Pink*, 1967–68; *Art Make-Up, No. 3: Green*, 1967–68; *Art Make-Up, No. 4: Black*, 1967–68; 10 min. loop

Twentieth-Century Purchase Fund, 1974.229a–d

Good Boy Bad Boy
1985

Two color videos, sound, two monitors on two pedestals; Tape I (male): 60 min. loop, Tape II (female): 52 min. loop

Gift of Lannan Foundation, 1997.150

Clown Torture
1987

Four-channel digital video, sound (two projections, four monitors); 60 min. loop
Tape I/Reel A: "Clown Taking a Shit"
Tape II/Reel B: "Clown With a Goldfish,"
"Clown With Water Bucket," Reel C: "Pete and Repeat," Reel D: "No, No, No, No (Walter),"
Tape III/ Reel C: "Pete and Repeat,"
Reel D: "No, No, No, No (Walter),"
Reel B: "Clown With Goldfish," "Clown With Water Bucket"
Tape IV/ Reel D: "No, No, No, No (Walter),"
Reel B: "Clown With a Goldfish," "Clown With Water Bucket," Reel C: "Pete and Repeat"

Watson F. Blair Prize, Wilson L. Mead and Twentieth-Century Purchase funds; through prior gift of Joseph Winterbotham; gift of Lannan Foundation, 1997.162

Bruce Nauman is a wildly influential artist whose work has explored the poetics of confusion, anxiety, boredom, entrapment, and failure since the 1960s. In many of his important early efforts, the artist used his own body as the vehicle for exploration. In *Art Make-Up, Nos. 1–4* (opposite), he applies colored makeup—white, pink, green, and finally black—in successive layers to his face and torso, introducing the themes of surveillance and masking that recur in his later creations. Like his entire oeuvre, *Art Make-Up* can be read as a self-conscious investigation into the conditions and possibilities of art making itself.

Nauman was a key figure in the experimental film and video movement of the late 1960s and early 1970s with such works as *Dance or Exercise Around the Perimeter of a Square (Square Dance)* (p. 15). After 1973, film and video become conspicuously absent from his work, replaced largely by language-based neon sculptures. He returned to video more than a decade later, with *Good Boy Bad Boy* (p. 20). Of this decision, the artist recalled, "I think it's because I had this information that I didn't want to put into a neon sign. . . . I had thought about presenting it as a performance, but I have never felt comfortable with performance. And so video seemed to be a way to do it."[1] Conceived as a didactic moral statement, the installation employs two actors, Joan Lancaster and Tucker Smallwood, who are presented in close-up, like newscasters, on two separate monitors. Each recites a one-hundred-line commentary on the human condition that includes passages such as "I was a good boy/You were a good boy/We were good boys" and "I hate/You hate/We hate/This is hating." Directly confronting the viewer, they deliver each repetition with increased emotional intensity, shifting in and out of sync with one another.

Installed in an enclosed, darkened space, *Clown Torture* (p. 21) consists of two rectangular pedestals, each supporting two pairs of stacked color monitors (one turned upside down, one turned on its side); two large, color-video projections on facing walls; and sound from all six video displays.[2] The monitors play four narrative sequences in perpetual loops, each chronicling an absurd misadventure of a clown, who is played to brilliant effect by the actor Walter Stevens. According to the artist, distinctions may be made among the clown protagonists; one is the "Emmett Kelly dumb clown; one is the old French Baroque clown; one is a sort of traditional polka-dot, red-haired, oversized show clown; and one is a jester."[3] In "No, No, No, No (Walter)," the clown incessantly screams "No!" while jumping, kicking, or lying down; in "Clown with Goldfish," he struggles to balance a fish bowl on the ceiling with the handle of a broom; in "Clown with Water Bucket," he repeatedly opens a door that is booby-trapped with a bucket of water, which falls on his head; and finally, in "Pete and Repeat," he succumbs to the terror of a seemingly inescapable nursery rhyme: "Pete and Repeat are sitting on a fence. Pete falls off. Who's left? Repeat." Of his work, Nauman has said, "From the beginning I was trying to see if I could make art that . . . was just there all at once. Like getting hit in the face with a baseball bat. Or better, like getting hit in the back of the head. You never see it coming; it

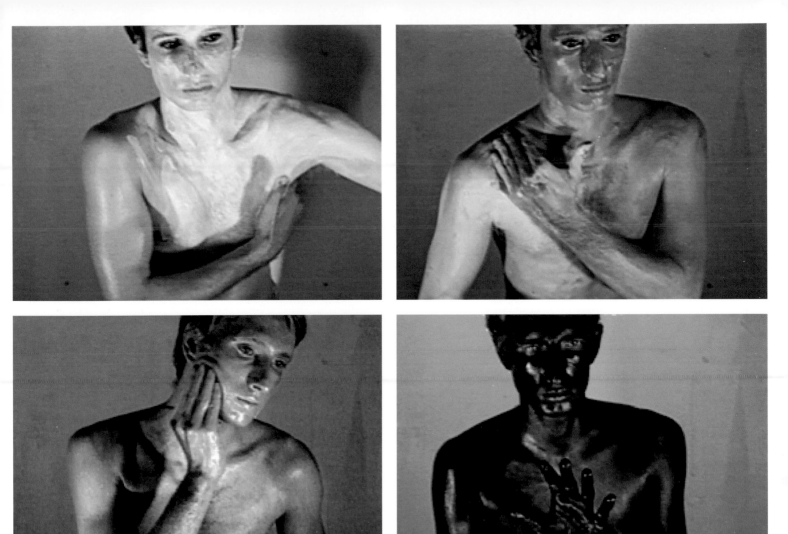

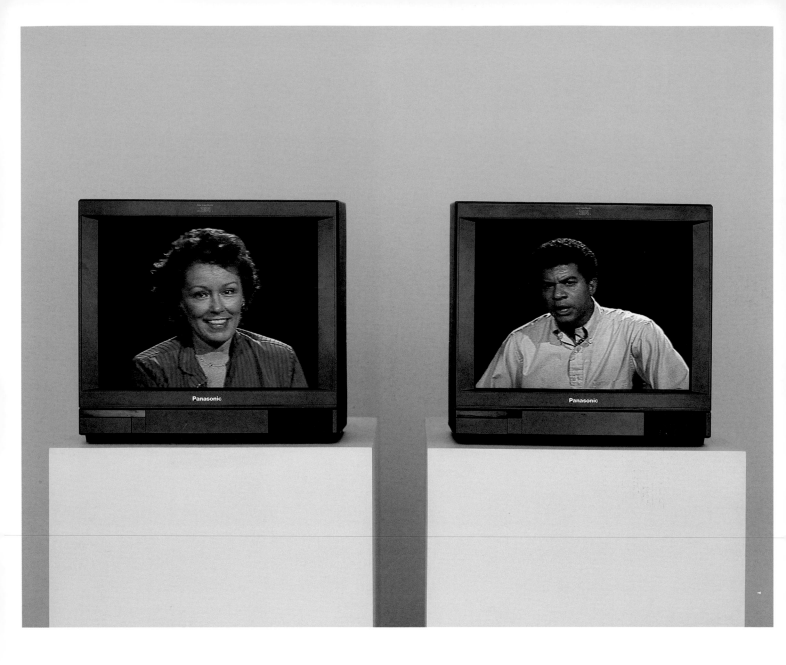

just knocks you down. . . . The kind of intensity that doesn't give you any trace of whether you're going to like it or not."[4] *Clown Torture* functions in very much this way: as an assault on viewers' aural and visual perception. One of Nauman's most spectacular achievements in video installation, it marked a major new direction and prefigured his recent, more complex environments involving monitors, projections, and other sculptural elements.

L.D./J.R.

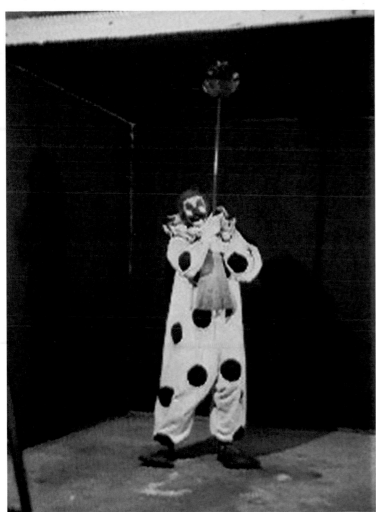

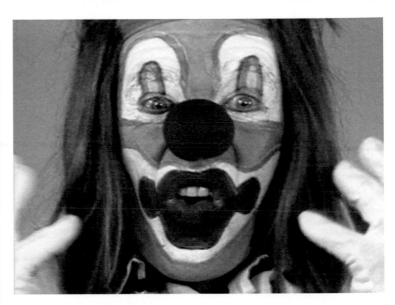

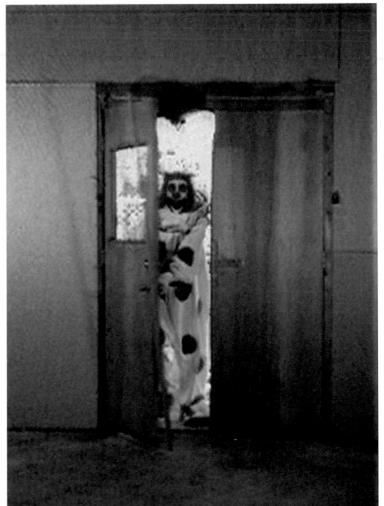

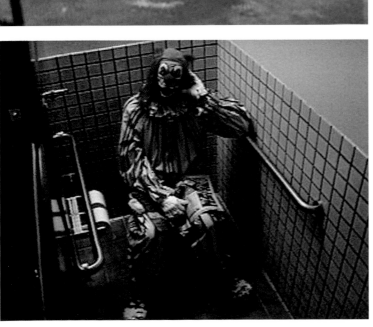

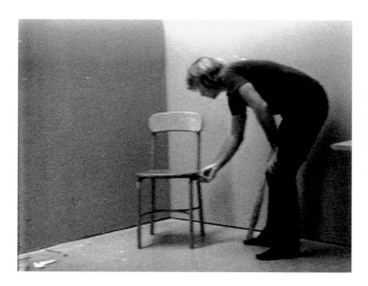

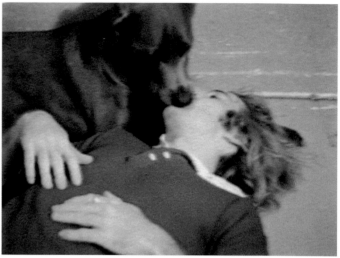

William Wegman

American, born 1943

Selected Works

1972–73

Black-and-white videos, sound;
Reel Two: 10 min., Reel Three: 16 min.

Twentieth-Century Purchase Fund, 1974.224a–b

At once amusing and enigmatically strange, William Wegman's work employs a wide variety of media, including painting, photography, text, and video. Wegman was among the first generation of video artists, and over the course of his career he has made over 150 works in the medium. The selection presented here was shown alongside Bruce Nauman's *Art Make-Up, Nos. 1–4* (p. 19) in the Art Institute's 1974 exhibition *Idea and Image in Recent Art*.[1]

In the early 1970s, Wegman began filming his own experimental performances, creating pieces that were a combination of documentation, parody, and subtle criticism of art making and artists, including himself. Within these, he demonstrated his fascination with linguistics and semiotics through the use of palindromes, puns, and fragmentary dialogue. Wegman was not alone in this interest—in the early 1970s, prominent artists such as John Baldessari (see pp. 66–67), Bruce Nauman (see pp. 18–21), and Ed Ruscha (see pp. 16–17), among others, shared his focus on language.[2]

Selected Works is composed of short videos whose durations range from sixteen seconds to just over four minutes. Reels two and three include playful demonstrations and sales pitches for fictional consumer goods that take the form of television advertisements and infomercials.[3] In *Massage Chair* (above, at left), for example, Wegman talks for more than a minute as he attempts to pass off an uncomfortable plastic chair as a revolutionary invention. Other works in the compilation involve the artist's Weimeraner, Man Ray, his faithful companion and collaborator for over twelve years. While the works featuring Wegman alone are often humorous, Man Ray's presence is instantly endearing. In *The Kiss* (at right), Wegman lays on the floor with a bone in his mouth while Man Ray attempts to wrestle it away.

Wegman's videos, much like his other works, are economical yet poignant. At first glance, they are undoubtedly engaging as portraits of the relationship between humans and animals. Less expected, however, are the ways in which his early-1970s critique of television culture still resonates today.

K.M.B.

Bob Snyder

American, born 1946

Lines of Force

1979

Color video, sound; 10 min

Trim Subdivisions

1981

Color video, silent; 6 min.

Gift of Society for Contemporary Art, 1983.265–66

In over three decades of work, Bob Snyder has combined synthesized sound and visual imagery to great effect. He played an integral role in developing the Sound Art Department at the School of the Art Institute, where he has been a faculty member since 1974. While formally trained in music and composition, Snyder originally had ambitions as a painter and always maintained a strong interest in visual representation. His early experiments with oscilloscopes—which he used to visualize sound waves and accompany his musical compositions—naturally led him to video technology, which afforded further opportunities to blend the visual and the aural in innovative ways. Among the original collaborators with Dan Sandin at University of Illinois-Chicago's Circle Graphics Habitat, Snyder was in the vanguard of formal video investigations with the Sandin Image Processor and other experimental equipment.[1]

Modulating between abstract and representational images, *Lines of Force* (above, at left) uses found footage from a variety of sources, including a classified weapons testing film produced by the United States Army, segments from the 1973 movie *Psychomania*, and various selections from broadcast television. The artist described using the editing technique of the match cut—juxtaposing things that happen to resemble each other within the same frame—as a way of creating visual puns.

Trim Subdivisions (at right) constitutes a departure from much of Snyder's work in that it has no soundtrack.[2] The artist created this purely visual composition with the most sophisticated digital effects and editing techniques of the day, which enabled him to manipulate images of tract-house facades that he shot in suburban Indiana. The silence is palpable, adding to the eerie quality of the oppressively uniform architecture.

L.D.

Bill Viola

American, born 1951

The Reflecting Pool, Collected Works

1977–80

The Reflecting Pool

1977–79, 6:58 min.

Moonblood

1977–79, 12:48 min.

Silent Life

1979, 13:14 min.

Ancient of Days

1979–81, 12:21 min.

Vegetable Memory

1978–80, 15:13 min.

Color video, sound (projection); 62 min. loop

Gift of Society for Contemporary Art, 1983.277

Reasons for Knocking at an Empty House

1982

Color video, sound (monitor), wood chair, headphones, spotlight, and pedestal; dimensions vary with installation

Restricted gifts of Barbara Bluhm, Frances Dittmer, Ruth Horwich, Susan and Lewis Manilow, Marcia and Irving Stenn, Jr., Dr. and Mrs. Paul Sternberg, and Lynn and Allen Turner; through prior acquisitions of Leigh and Mary Block, 1993.246

For over thirty years, Bill Viola has created single-channel videos as well as sound and video installations that focus on spirituality and explore multiple levels of human consciousness. In constructing these works, the artist draws from his extensive study of Eastern and Western art, philosophy, and religion. He also consistently deploys cutting-edge technologies, investigating new ways to manipulate viewers' perception.[1] Both the videos in *The Reflecting Pool* and the installation *Reasons for Knocking at an Empty House* are important early works that foreshadow Viola's later creations, combining philosophic inquiry with captivating physical environments.

The Reflecting Pool is a series comprising five individual videos, including *Moonblood* (at middle), that offer a collective meditation on the various stages in an individual life. The first work, also titled *The Reflecting Pool* (at top), demonstrates the shift from stillness to motion as a fixed camera captures a man approaching a pool of water through trees and lush foliage. The only sounds are those of the branches rustling and the water rippling. The man momentarily stands before the pool before jumping into the air. As he reaches the crest of his jump, he is frozen in space while the water beneath him continues to undulate. There is a fleeting reflection of other people walking around the pool, although no one can be seen doing so. After a series of similar perceptual and temporal fragmentations, the man's image fades, leaving only the pool. The final moments of the video are evocative of baptism, as a nude man emerges from the water and retreats into the woods.

In this series, Viola aims to deconstruct viewers' concepts of time and memory, divorcing images from their subjective meaning and reconnecting them to universal truths. This process of fostering self-awareness is an undercurrent of the artist's practice. He has remarked, "There's another dimension that you just know is there, that can be a source of real knowledge, and the quest for connecting with that and identifying that is the whole impetus for me to cultivate these experiences and to make my work."[2]

The haunting *Reasons for Knocking at an Empty House* (at bottom) contains a solitary wood chair with headphones attached, facing a television monitor. Viola, looking visibly fatigued, appears on the screen, sitting in his own chair. Here, the artist compels viewers into an intimate relationship: they sit at eye level with him, listening to the sound of his breathing through the headphones. The silence and tension in the installation is disrupted at irregular intervals by a dissonant, jarring sound that echoes throughout the gallery. At the same time, Viola is hit over the head with a magazine. Taken as a whole, the work suggests a scene of execution or torture, with its single chair and its haggard artist, sleep-deprived and assaulted while seated alone in an empty room.

In both *The Reflecting Pool* and *Reasons for Knocking at an Empty House*, the artist urges viewers to become active participants. Of his work, Viola stated, "You're a part of it. It's not something that's just a fixed projection from the past."[3]

K.M.B.

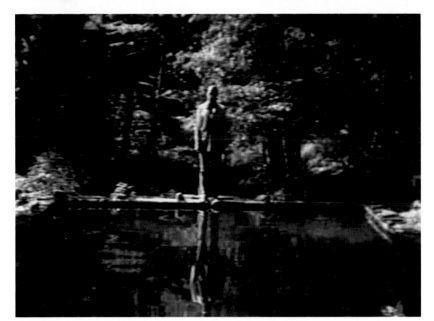

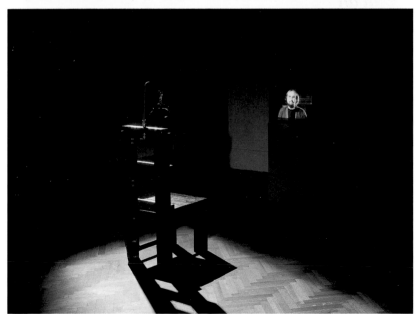

Nam June Paik

American, born Korea, 1932–2006

Family of Robot: Baby

1986

Color video, silent, thirteen monitors and aluminum armature; 133.3 x 96.2 x 20.3 cm (52 1/2 x 37 7/8 x 8 in.)

Gift of Society for Contemporary Art, 1992.283

A pioneering figure in electronic art, Nam June Paik was among the first to use television as an art form. Originally a composer of experimental and electronic music, he created performance work within the context of the Fluxus movement in the 1950s. The artist viewed his musical instruments as "objects with visual qualities," which allowed him to move fluidly from using sound to incorporating images into his creations.[1] Having begun exhibiting works with televisions in 1963, Paik was one of the earliest artists to use a Sony Portapak (the first portable video recording device) after it became available in 1965, producing his initial multimonitor video sculptures the following year.[2]

Family of Robot, the first series of video sculptures that Paik created, consists of three generations of family members, including a grandmother and grandfather; mother and father; aunt and uncle; and children. Paik pursued the theme of generational difference through his choice of materials, providing a unified history of family and technology. Viewed as a whole, this group of anthropomorphic sculptures incorporates media hardware from various stages of its evolution in the twentieth century. The grandparents' heads are constructed of 1930s radios and their bodies of 1940s television frames refitted with Sony or Quasar screens, while the parents' heads are more recent than their bodies. The children, including *Baby*, are made of newer televisions. In some cases, the children's heads are two decades more advanced than their bodies, and in others, both sections are made of uniform parts. The Art Institute's *Baby*—one of nine unique baby robots—was assembled from thirteen Samsung monitors, which at the time were the most up-to-date equipment manufactured in Korea. The monitors are placed in different directions in the aluminum armature, depending on the section of the body they represent.

In *Family of Robot*, television is used not as a means of disseminating information but rather as a more decorative element. Like its relatives, *Baby* displays an artist-created videotape—in this case, one that consists of flashing, vibrant images of hearts, psychedelic patterns, revolving bands and planets, and excerpts of newscasts depicting people, especially children, in Africa and India. Paik insisted that a balance should exist between nature and technology, a notion that he realized in this friendly looking figure, which is a remarkable product of his own time and effort.[3]

With this series, Paik suggested that technology is both a product of human innovation and a potential cause of our retreat from reality. In a sense, he explicitly humanized technology as a means of resistance, commenting, "One must . . . know technology very well in order to be able to overcome it."[4] Stating that the purpose of video art is "to liberate people from the tyranny of TV," he was perhaps reminding us of the capability of technology—or, more specifically, of broadcast television—to consume our lives, and asserting the need for us to see it in a different form, such as art.[5] Although *Baby*'s televisions are now dated themselves, this obsolescence only enhances the work's ability to evoke the rapid transformation of technology.

E.J.

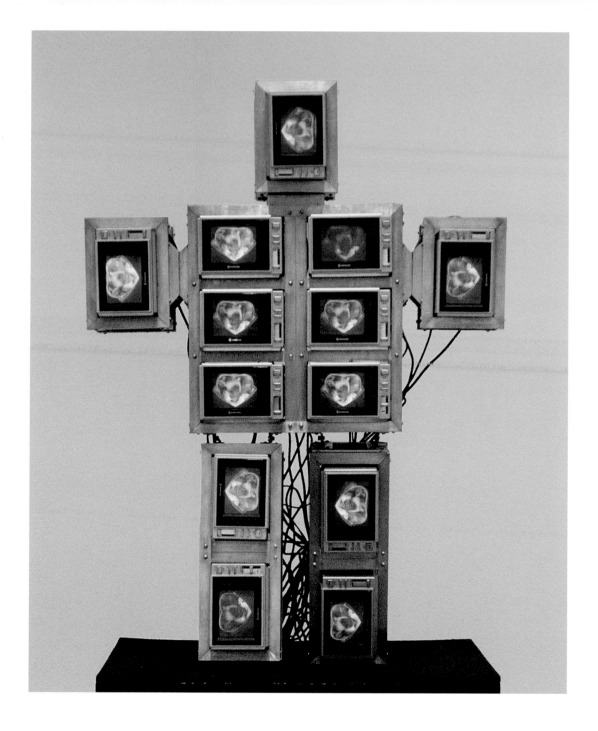

Gary Hill

American, born 1951

Inasmuch As It Is Always Already Taking Place

1990

Sixteen-channel black-and-white video, sound (sixteen cathode ray tubes); 5- to 30-second loops; 16 x 54 x 66 in. (40.6 x 137.2 x 167.6 cm), niche recessed into wall

Gift of Lannan Foundation, 1997.144

Gary Hill's video installations investigate the complex relationship between language and images. In the 1970s, Hill experimented first with sound installations and then a video recorder. In the 1980s, alongside other video artists such as Bruce Nauman (see pp. 18–21) and Bill Viola (see pp. 24–25), he began to focus on the technical capabilities of the medium rather than its aesthetic qualities, seeking to create a meditative space where he could explore issues of authorship, consciousness, and semiotics.

Like other works by Hill, *Inasmuch As It Is Always Already Taking Place* is an amalgam of visual, structural, and sound components. The piece consists of sixteen staggered, uncased monitors that display life-size male body parts, pages of a book being thumbed, and a page with text that is too small to read. Varying in size from one-quarter inch (an eyepiece of a video camera) to twenty-three inches (the size of a ribcage), the screens, with their exposed, nervelike wires, are recessed into a five-foot niche that is set below eye level. The fragmented figure's subtle movements are juxtaposed with nearly inaudible speech, primitive sounds of groaning, smacking noises, finger tapping, rippling water, and gun shots. Moving in close enough to decipher the sound, the viewer hears intermittent statements including "It was only an idea" and "I couldn't say it any other way," as if the body has its own language.

Rooted in Poststructuralist theory, including the work of French philosopher Maurice Blanchot and others, Hill's practice merges the visual and literary arts. As he has said, "My preoccupation with language began with very sculptural notions coming out of sound, the body, utterance and speaking."[1] In *Inasmuch As It Is Always Already Taking Place*, Hill adds a layer of language and deconstructs his own body, focusing on the scene as a whole rather than on each individual image. The dismembered body is decidedly self-referential, appearing as a random pile, or, as Hill put it, "a kind of debris."[2] Abstracted, it exudes a sensation of presence and absence, having become barely recognizable despite its close-up detail. On one level, Hill seems to be challenging a notion of masculine authority by revealing and fracturing an image of male nudity.

Unmoored from their usual spatial and temporal relationship to one another, these body parts are treated almost as a still life or landscape painting. Indeed, the work can be seen as a vanitas image; the visceral sounds and the barely moving, harshly lit figure are the only signs of life and thus serve as reminders of its transience—and perhaps also of the impermanent nature of electronic media.[3] This disturbing and complex video installation suggests many dichotomies: being and knowing, self and other, private and public, reality and imagination.[4]

E.J.

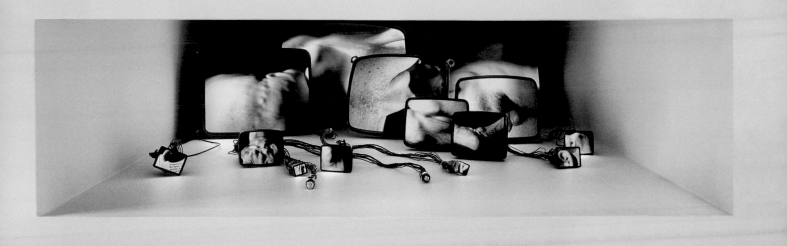

William Kentridge

South African, born 1955

Johannesburg—2nd Greatest City after Paris

1989

16mm color film, sound, transferred to digital video (projection); 8:02 min.

Monument

1990

16mm color film, sound, transferred to digital video (projection); 3:11 min.

Mine

1991

16mm color film, sound, transferred to digital video (projection); 5:49 min.

Sobriety, Obesity & Growing Old

1991

16mm color film, sound, transferred to digital video (projection); 8:15 min.

Gift of The Peter Norton Family Foundation, 1998.353–56

Ubu Tells the Truth

1997

35mm color film, sound, transferred to digital video (projection); 8 min.

Gift of Donna and Howard Stone, 2007.38

William Kentridge's interdisciplinary practice includes animated films, drawings, and installations, as well as theatrical and operatic direction. Through these diverse media, the artist, who was born and raised in Johannesburg, explores the impact of social history and political upheaval on the human condition. Although South Africa serves as his primary source, his analysis and the works it informs contain allegorical narratives that incorporate universal themes of good and evil, power and freedom. Kentridge explained, "I have never tried to make illustrations of apartheid, but the drawings and the films are certainly spawned by, and feed off, the brutalized society left in its wake. I am interested in a political art, that is to say an art of ambiguity, contradiction, uncompleted gestures and uncertain endings. An art (and a politics) in which optimism is kept in check and nihilism at bay."[1]

Kentridge creates his animated films through a time-consuming process of over-laying, redrawing, and erasing marks on a small number of large charcoal and pastel drawings. He alters the image for each shot, leaving obvious traces of past states in nearly every frame; this layered effect inadvertently becomes a metaphor for the impact of historical memory on the present. As Kentridge has stated, "The very term 'new South Africa' has within it the idea of a painting over of the old, the natural process of disremembering, the naturalization of things new."[2] *Drawings for Projection* is the name that Kentridge uses to refer to his series of films that includes *Johannesburg—2nd Greatest City after Paris* (opposite, at top), *Monument* (at bottom), *Mine* (p. 32), and *Sobriety, Obesity & Growing Old* (p. 33, at top).[3] Created while apartheid was being dismantled, these films examine the lives of two South African men and their relationships (both complicit and oppositional) to the structures of oppression. Kentridge himself is Anglo-Jewish, and his two protagonists, Soho Eckstein and Felix Teitlebaum, represent two opposing stereotypical notions of Jewish identity, existing as alter egos. Felix, cast as a sensitive dreamer, wanders through the tumultuous landscape of postcolonial South Africa naked, lost, and often alone. An exaggerated portrait of the Jewish intellectual, he seems to bear the social and moral conscience of an entire troubled nation. Soho, a cigar-smoking industrialist dressed in a pinstriped suit, represents the quintessential corporate fat cat associated with the greedy, corrupt, and oppressive elements of South African society. As the four films unfold, however, both Felix and Soho evolve and grow, demonstrating a much greater degree of complexity than might be expected.

Ubu Tells the Truth (p. 33, at bottom) is based on Alfred Jarry's 1896 play *Ubu Roi*, a satire about an archetypal character who abuses his power and embodies humanity's most negative aspects. Inspired by testimony given during the hearings of the Truth and Reconciliation Commission, which was set up by the South African government in 1995 to investigate human rights abuses under apartheid, Kentridge originally conceived this work as a series of eight etchings and also transformed it into a theatrical performance.[4] In the animated film, the artist interlaced documentary footage and photographs depicting narratives of daily life, combining terrible acts of murder and torture with cartoonish depictions of the fictional dictator Ubu to

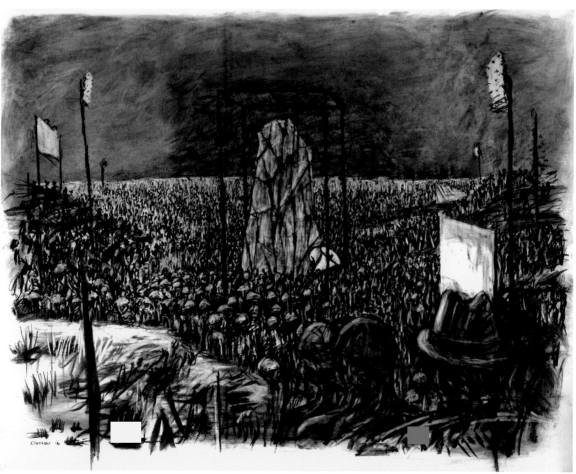

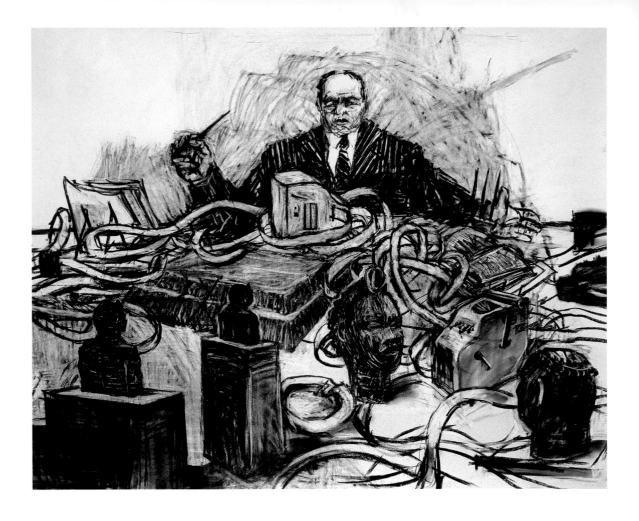

relate actual experiences of public trauma. Kentridge situated Jarry's character within a familiar contemporary setting, stressing the more burlesque aspects of the original and presenting him as the dangerous yet laughable embodiment of power and evil.

Kentridge's musical accompaniment to his films is an important element of their character development and emotional impact. Whereas the artist had some compositions specifically arranged for the films in *Drawings for Projections*, he chose others from sources as diverse as Antonin Dvořák, Duke Ellington, and South African choirs. The powerful reunion of Soho and his wife at the end of *Sobriety, Obesity & Growing Old*, for example, is enriched by the aria "*M'appari tutt'amor*" from Friedrich von Flotow's opera *Martha* (1847). At times sound is shown emanating from loudspeakers, as when Felix sits on and near them, listening, as one critic put it, "to the world."[5]

Evocative of the figuration and political scenes of William Hogarth, Francisco Goya, and Max Beckmann, Kentridge's art addresses contemporary issues of capitalism and power, guilt, and responsibility. His unscripted films are process driven, engaging in and reflecting upon the political history of South Africa while creating nuanced, ambiguous narratives with larger, more universal implications.

J.G.

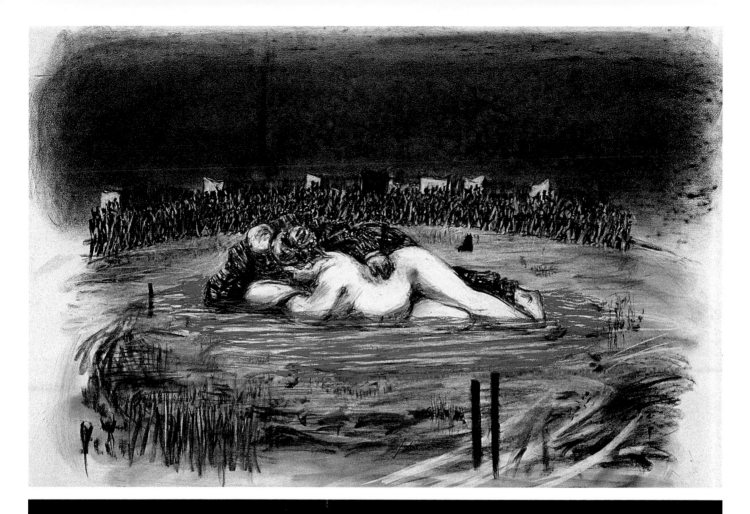

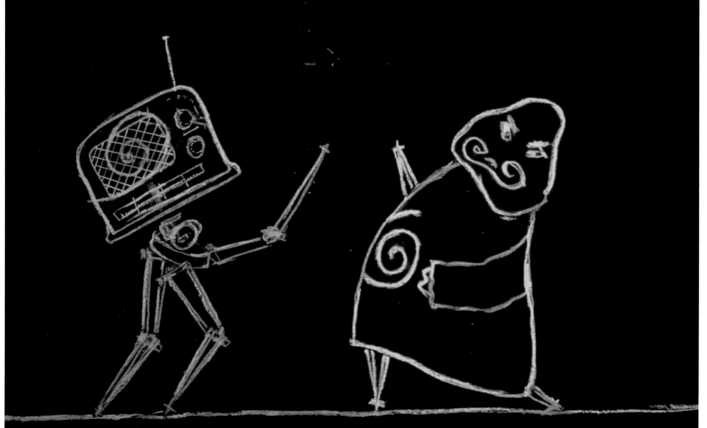

Iñigo Manglano-Ovalle

American, born Spain, 1961

Sonambulo II (Blue)

1999

Compact disc, blue-tinted polyester window film, existing architectural space; 13 min. loop

Jacob and Bessie Levy Art Encouragement Fund, 1999.299

Iñigo Manglano-Ovalle first gained international recognition for a diverse body of work—consisting of both studio-based objects and activist-inspired public art—that blended contemporary urban culture with poetic meditations on aesthetics, nature, and beauty. *Sonambulo II (Blue)* speaks precisely to the crucial intersection between his earlier street-based endeavors and his later, more gallery-bound practice. Importantly, it exists as both an individual work of sound art and a site-specific installation commissioned by the Art Institute.

Consisting mainly of the soothing sounds of a summer thunder- and rainstorm, the audio portion mimics a New Age relaxation tape or therapeutic sleep aid. The origins of the work, however, are quite different: the audio was composed from the sound of a single gunshot that the artist sampled and digitally remastered using state-of-the-art computer editing equipment. The sound loop begins with the explosion of the gunshot, which is followed by eight seconds of tense silence. The gunshot sound is then repeated 385,000 times and seamlessly blended with the beginnings of the simulated thunder. The rainstorm effect follows, and the piece automatically repeats.

The conceptual roots of the work can be found in Manglano-Ovalle's biography. An insomniac, he decided to construct his own relaxation tape directly from the very street noises that were contributing to his sleeplessness. Placing a microphone outside his bedroom window on Chicago's Northwest Side, he captured the sound of gunfire in a single night.[1] In a poignant act of creative transformation, the artist constructed an escape based in reality, turning the potentially frightening sounds of violence into a soothing means of respite. Sound itself, however, is also a major focus of his thinking: "I don't use sound in a linear, time-based way. To me sound is very much an extension of sculpture. It has physical form to me. It drives and also occupies space."[2]

Sonambulo II (Blue) is much more than a personal lullaby: Manglano-Ovalle's strikingly inventive manipulations contain a compelling social critique. The references to sleep introduce the metaphor of unconsciousness and consciousness. Extending these into the arena of pressing political issues such as gun violence, the work points to the basic differences between awareness and ignorance, social action and neglect. The piece masks the sounds of gunfire with the effect of a natural phenomenon; in doing so, it suggests the ways in which violence and fear too often become the ambient backdrop of contemporary urban life.

In the Art Institute's 1999 installation, shown here, viewers were invited to experience the work's artificial nature while contemplating the actual urban landscape, which was beautifully framed by a wall of tall glass windows in the museum's Rice Loggia. Hermetically insulated from the exigencies of day-to-day street life, visitors were actually suspended above the cityscape. This artifice, further heightened by the blue tint of the windows, created the effect of imitation rain meeting imitation sky.

L.D./J.R.

34

Tacita Dean

English, born 1965

Disappearance at Sea II (Voyage de Guérison)

1997

16mm anamorphic color film, optical sound; 4 min. loop

Gift of Society for Contemporary Art, 2000.97

Beginning in the late 1990s, Tacita Dean has produced numerous drawings and photographs, extensive writings about her work, and, most impressively, over thirty films. These works are often low-tech and employ highly economical means of shooting, such as a fixed camera, limited angles, or slow pans. Although many of her films are based loosely on a fictional or historical tale, the artist's real power lies not in storytelling but in her adeptness with the medium of film itself. Her narratives are deeply rooted in film's relationship to light and time, and to the reflexive and circuitous nature of both these elements.

Disappearance at Sea II (Voyage de Guérison) is the title of a short film made after *Disappearance at Sea (CinemaScope)* (1996). Both works take as their point of departure the story of Donald Crowhurst, an amateur yachtsman from England who joined the solo, round-the-world *Sunday Times* Golden Globe Race in 1968. The inexperienced (and, some might say, deceptive) Crowhurst quickly ran into difficulties, and eventually his craft, the *Teignmouth Electron*, was found several hundred miles from the coast of Britain, abandoned.[1] Filmed in panoramic format in northeast England, *Disappearance at Sea (CinemaScope)* uses the lights of Berwick Lighthouse and the surrounding landscape to suggestive narrative ends.

The title of *Disappearance at Sea II (Voyage de Guérison)* refers to the medieval legend of Tristan and Isolde's misguided, love-potion-induced affair. Tristan, unlike Crowhurst, embraced the ocean's power: after being mortally wounded, he allowed

himself to drift in a *voyage de guérison*, or journey of healing, to a magical island where he hoped to be cured once again by the powers of Isolde and her mother, the queen. Dean set the film at the Longstone Lighthouse in the Farne Islands, mounting the camera on the building's lighting apparatus. Using a wide-screen format, she confined her exploration to a single continuous shot. The uninterrupted rotation captures the reflections in the building's curved windows and an endless pan of the surrounding sea and sky. The implied narrative is one of silent, ceaseless waiting for a loved one to return from the sea; during exhibition, sound is confined to the light's mechanism and the rhythmic clicking of the projector, with the whirring of the film reel echoing the sound of the rotating lighthouse.

Reflecting on Dean's oeuvre, the novelist Jeannette Winterson wrote: "The vividness of her images and the vibrancy of her soundscapes are a challenge to the desensitised, coarse world of normal experience, where bright lights, movement and noise cheat us into believing that something is happening. Tacita Dean's slow nothingness is far more rich and strange."[2] Indeed, in this artist's work, real and cinematic space become analogous, forming an elegant symmetry between medium and subject.[3] *Disappearance at Sea II*, like its companion, is ultimately about the phenomenon of projection, of a beam of light being transmitted through a lens—in actuality, the essence of film.[4]

N.R.

Rineke Dijkstra

Dutch, born 1959

Annemiek, February 11, 1997

1997

Color video, sound (projection); 4 min. loop

Modern and Contemporary Discretionary Fund, 2000.312

Rineke Dijkstra practices an art of quiet, engaged observation. Since she began exhibiting her photographic work in 1993, she has developed an international reputation as one of the most visible and highly regarded Dutch artists of her generation. She is known for flat, frontal, color portraits of individuals that are characterized by a remarkable formal classicism, conceptual rigor, and psychological depth. Of her work, the artist has commented, "I discovered that if you want to give a general impression, you should be very specific."[1] In the series *Beach Portraits*, for instance, she depicts her subjects within a precise geographic setting yet avoids identifying them by name.[2]

Although video is somewhat of an anomaly in Dijkstra's oeuvre, her earliest attempts in the medium, like her photographs, focus on the tender aspects of teenage sexuality and social behavior. For instance, both *Buzz Club/Mysteryworld* (1997) and *Annemiek, February 11, 1997* feature subjects that were filmed alone or in groups, appearing before a blank white background. *Buzz Club*, however, grounds these individuals within their wider location—a nightclub in Liverpool—through the use of ambient noise as well as through their unselfconsciousness in front of the camera; although they stand in front of a screen, they continue to smoke, dance, and chew gum. In this way, *Buzz Club* serves as a stylistic and compositional bridge between Dijsktra's photographic portraits and *Annemiek*.

Dijkstra shot *Annemiek* with a single fixed camera, and only the subject's head and shoulders are visible in the frame. The work features an adolescent Dutch girl alone before the camera, lip-synching the ballad "I Wanna Be With You" by the popular American teen band the Backstreet Boys. As the music starts, Annemiek appears nervous and embarrassed, but only moments later she furrows her brow in a momentary lapse of self-consciousness, allowing herself to intimate the lyrics' passion. Quickly catching herself, she manages a bashful smile. Throughout the video, she continues to struggle between this adolescent awkwardness and adult confidence.

K.M.B.

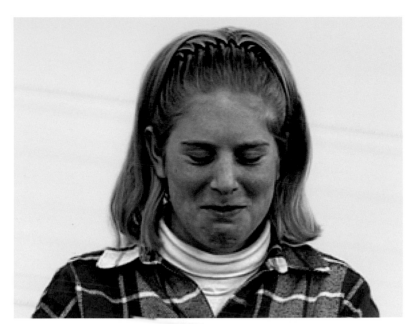
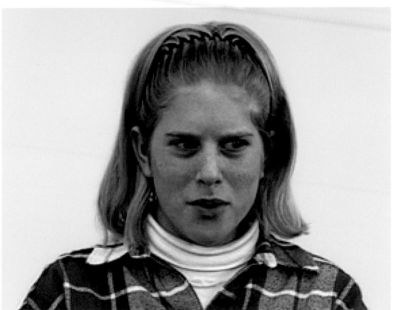
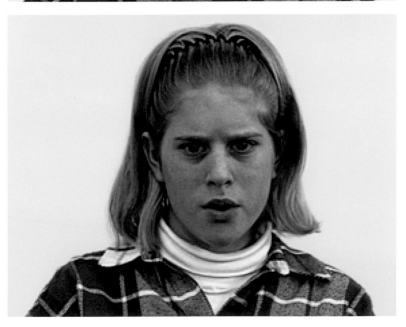

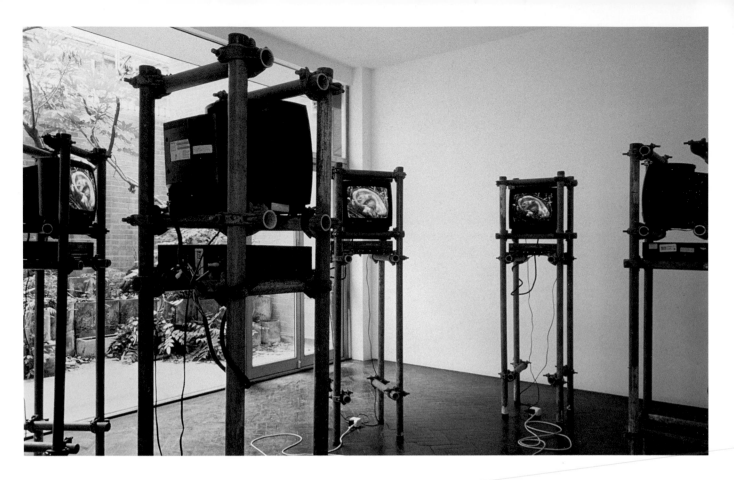

Kendell Geers

South African, born May 1968

Tears for Eros

1999

Color video, sound (five monitors), metal
scaffolding; dimensions vary with installation

Donna and Howard Stone New Media Fund,
2000.48

Kendell Geers is known both for his activist-inspired performances and conceptual, politically charged, and often controversial artworks.[1] Like other contemporary artists such as William Kentridge (see pp. 30–33) and Yinka Shonibare, who also address issues relating to the history of Africa, Geers draws on firsthand experience of the traumas of colonialism while reflecting on wider issues of global culture. A white man from a working-class Afrikaans family, the artist has developed a practice that engages with the turbulent revolution surrounding the downfall of apartheid and the burden of his country's past. In the late 1990s, he began creating intense, unsettling video installations that reshape imagery from Hollywood films to delve into themes of collective guilt, confrontation, and violence.

Tears for Eros consists of five video monitors supported by scaffolds, an arrangement that Geers refers to as "information towers." Each channel presents close-up footage, appropriated from David Lynch's debut film *Blue Velvet* (1986), of a severed human ear lying in a field of grass. In quickly edited sequences, an army of black ants moves in and around the ear, accompanied by the ambient noise of cicadas and chirping crickets. Although the color balance and tone of each monitor is different, the sequence appears to be nearly identical on all five channels, generating a relentless, numbing effect.

Careful scrutiny reveals that the respective visuals are in fact composed of many different edits of the sequence, and the audio—similarly misleading—is a manipulated version of the movie's soundtrack that incorporates electronic noise and recordings of heavy industry. In this chilling tableau, hints of violence and decay are inextricably linked to the natural landscape. The image of a severed ear itself is hardly coincidental: through manipulations of one powerful moment from Lynch's film, Geers suggests a condition in which we are stripped of our own senses, bereft of an ability to discern truth from fiction.

K.L.

Helen Mirra

American, born 1970

Map of Parallel 52 North at a Scale of One Foot to One Degree

1999

Hand-painted 16mm color film, silent, with film reel, can, and lid in vitrine; 11 min. loop

Ann M. Vielehr Prize Fund, 2001.485

Helen Mirra's widely varied production includes film, poetry, recorded music, sculpture, and video. Like many other practitioners of her generation, she has adopted and reconfigured the strategies of Conceptual Art to personal, often narrative, ends. Much of her work pairs ideas of travel and labor, with particular attention to themes of landscape, the sea, and childhood. Restricted to a palette of drab greens, browns, and blues, her creations are distinctly evocative of the natural landscape.

Map of Parallel 52 North at a Scale of One Foot to One Degree represents an imaginary aerial circumnavigation of the globe, beginning and ending off the coast of Labrador. At this scale, the film is precisely 360 feet long, and its journey across the North Atlantic, Ireland, England, the Netherlands, Germany, Poland, Belarus, the Ukraine, Kazakhstan, southern Russia, the Bering Sea, and southern Canada takes only eleven minutes from start to finish. At early screenings, Mirra's presence added a performative aspect, as she would call out the names of locations along the way.[1] Like many of her sculptures, the film is displayed at floor level; the presence of the reel, can, and lid within a nearby vitrine draws further attention to the work's materiality.

On the film itself, meandering brushstrokes send viewers into a sort of reverie, as the visual information flickers and moves too quickly to be followed. The artist eschewed traditional cartography in favor of translating the geography of this line of longitude into green and blue watercolor washes that represent land and water, and that were painted directly onto the film's clear surface. In particular, the rapid variations in brightness of color recall flicker films, which are characterized by a similar visual quality and induce equally trancelike effects. Evoking the histories and practices of film, painting, and sculpture, Mirra's work is a quietly powerful meditation on the human practice of understanding the world.

K.M.B.

Joshua Mosley

American, born 1974

Beyrouth

2001

Digital color video, sound (projection);
9 min. loop

Pauline Palmer Prize Fund, 2003.87

A Vue

2004

High-definition color video, sound
(projection); 7:30 min. loop

Gift of Donna and Howard Stone, 2007.45

dread

2007

High-definition color video, sound
(projection), 6 min. loop

Wilson L. Mead Fund, 2008.80

Joshua Mosley's stunning, often cryptic work, which involves a labor-intensive combination of drawing, high-definition video, photography, and sculpted stop-motion figures, has redirected the leading edge of animation technology away from its origins in collective production models and commercial applications, and into the visionary realm of the individual artist and the fine-art short film.[1]

In *Beyrouth* (at top), Mosley depicts an imaginary philosophical debate between his Lebanese grandfather, represented by a twelve-year-old boy in braids, and his great-grandfather, portrayed as a white donkey. The piece has its origins in a libretto that was inspired by the artist's conversations with his grandfather, an etching by Francisco de Goya featuring a donkey, and English translations of short stories by the Argentine writer Julio Cortázar. Mosley wrote his libretto in English, translated it into Spanish, back into English, and finally into Arabic. Like much of his work, including *A Vue* and *dread*, *Beyrouth* explores the behavioral rules of conversation and the structure of dialogue. In this case, the libretto developed into an operatic soundtrack created in collaboration with composer Toufic Farroukh and inserted within the enigmatic, dreamlike film.

A Vue (at middle) recounts the story of Henry, a park ranger who has devoted his life to maintaining a gigantic bronze statue of George Washington Carver. The narrative develops when Henry meets Susan, who works at a fiber optics company. As the couple discuss the relationship between their lives and their jobs, it becomes increasingly difficult to distinguish an admirable task from a meaningless one. The statue of Carver remains motionless while ink wash drawings move unsteadily around it. Serving as an exploration of dedication to work rather than a mere tribute to an American hero, it symbolizes the dichotomy inherent in work, questioning whether this common means of self-definition might instead be a mechanism for self-obliteration. The musical score, written in collaboration with Abby Schneider, adds a grim intensity to the piece.

The dialogue in *dread* (at bottom), meanwhile, is loosely based on the artist's reading of Blaise Pascal's *Pensées* (1670) and Jean-Jacques Rousseau's *Emile* (1762). Mosley was interested in the way that both texts "present the difficulty of resolving the human relationship to nature and existence while also accepting God as the creator."[2] Here, the two philosophers encounter each other in a forest landscape and engage in a brief, esoteric debate that cannot be resolved; they are accompanied all the while by an original soundtrack made up of an intricate assembly of short recordings of single notes. The work's title refers to a huge dog that brings the men's deliberations to an untimely end. The animal's name and form recall the subject of Eadweard Muybridge's photographic motion study *Dog; Trotting; Mastiff-Dread* (1884/87), alluding both to the culture of nineteenth-century scientific investigation and to Muybridge's experiments as precursors to the motion picture.

L.D.

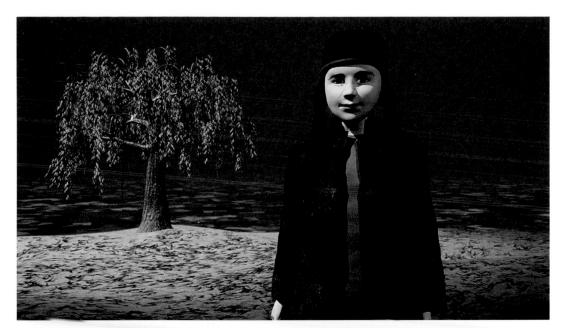

Zarina Bhimji

Ugandan, born 1964

Out of Blue

2002

16mm color film, sound, transferred to digital
video (projection); 24:25 min. loop

Restricted gift of Barbara Ruben in memory of
Thomas H. Ruben, 2004.147

In *Out of Blue*, Zarina Bhimji registers sense impressions of present-day Uganda through color, light, and texture. On the one hand, this is a place the artist has seen before: she lived in Uganda as a child, until General Idi Amin expelled thousands of South Asians from the country. On the other hand, however, she has made it clear that *Out of Blue* thoroughly transcends any biographical concerns: "The work is not a personal indulgence; it is about making sense through the medium of aesthetics. It is a question that is close to my heart since the significant ethical issues have a resonance for me. I want to register these issues, to mark what has happened: elimination, extermination, and erasure."[1]

Addressing these concerns through visual metaphors, Bhimji shaped *Out of Blue* by paying close attention to the intense beauty of her physical surroundings. For instance, the opening scenes show an expansive view of a verdant landscape that is soon overtaken by the crackle of flames and an all-encompassing fire. This conflagration perhaps recalls disturbances in places such as Kosovo, Rwanda, and Uganda—events, both personal and public, that continue to resonate in our consciousness. The fire also, however, serves as a dynamic formal element, since Bhimji is considering landscape in the broadest of ways. According to the artist, "It is the tension of translation, the exchange, the resonance between an extremely beautiful still landscape and the one on fire that gives energy and defines reality."[2]

In *Out of Blue*, the camera searches empty locations such as disused refugee dwellings, cemeteries, prison cells, and schoolyards, places that at once evoke British colonial rule and, more importantly, possess an evocative visual atmosphere. Bhimji also often focuses on the banal signs of present-day life: birds, insects, mats, and pots on the stove. Gunshots and chaotic voices are mixed into the soundscape, creating a sense of impending tragedy. The soundtrack includes the words of Sufi vocalist Abida Parveen, Idi Amin's radio announcements, children's voices, a woman's sobs, and layers of ambient sounds. In fact, the artist works with composers and does extensive research with sound archives prior to making a series of photographs or a film, creating her soundtracks independently and adding them in at the last phase of production. *Out of Blue*'s final scenes settle on Uganda's now-abandoned Entebbe International Airport, where tens of thousands of refugees attempted to leave the country. Here we witness the frenzied activity of ants taking over the deserted compound in a scene overlaid with chaotic music, mass voices, and sounds of struggle.

According to the artist, *Out of Blue* is, in its essence, neither memoir nor protest, but rather an open-ended, more purely aesthetic engagement with the processes of looking and understanding. "My work," she explained, "is about learning to listen to difference in its various forms. Listening with the eyes, listening to change in tone, difference of colour. It is not about capturing an existing thing; it is about creating a new one."[3]

N. R.

Charles Ray

American, born 1953

Fashions

1996

16mm color film, silent, projector, pedestal, and seating; 12:30 min.

Pauline Palmer Prize Fund, 2004.150

Since the early 1970s, Los Angeles–based artist Charles Ray has produced sculptural works that disorient viewers and command space in unusual ways, exploring its aesthetic and psychological implications. Influenced in part by the simplicity, emotional blankness, and serial quality of Minimalism, Ray chooses subjects that may at first seem simple but, upon closer observation, reveal an ambitious combination of formalism and technical complexity. Viewers experience cognitive dissonance when encountering Ray's works, which include life-size or larger than life-size mannequins and everyday objects. The artist's hyperbolic presentation of the real, whether overexaggerated—or, as in *Fashions*, underexaggerated—turns the ordinary into the hallucinatory.

In this, his only completed film, Ray shows his friend and former student Frances Stark, now a noted artist, modeling one hundred original outfits while rotating slowly on a small platform that he controlled. Standing in *contrapposto*, Stark attempts to mimic both the stoic pose of a classical statue and the stiffness of a modern commercial mannequin. However, her clearly visible tattoo, uneven tan lines, and blinking eyes signal that she is real. Given Ray's ongoing quest to at once objectify the living and animate the lifeless, *Fashions* is unusual in that humanity prevails.

As the title indicates, the focus is on the clothes, which Ray designed and then stapled or taped together. At the end of each rotation of the platform, the film cuts to a new ensemble, with absolutely no other action. As Ray described it, Stark becomes an "armature" on which to build his work, a means "to show off the labor."[1] Fashion is also used as a metaphor for identity; it can be interpreted differently depending on the beholder, fostering a false intimacy between the subject and viewer.

Fashions combines the ideas appearing in Ray's previous work with mannequins; his photographic piece *All My Clothes* (1973); and the sculptural *Tabletop* (1989), in which a bowl, potted plant, and other objects rotate slowly on a table.[2] According to the artist, *Fashions* also recalls his sculptural piece *Puzzle Bottle* (1973), for which he sealed a scaled-down figure of himself in a bottle, forming an abstract space that exists outside of time.[3] A film installation that should be viewed from beginning to end, *Fashions* is meant to be shown with a whirring, flickering 16mm film projector, a nearly outmoded format reminiscent of the ones used in Ray's high school.[4] The size, rotational speed, and mechanical movement of the film reel echoes that of Stark's platform, collapsing the difference between the projector and the image it displays.

E.J.

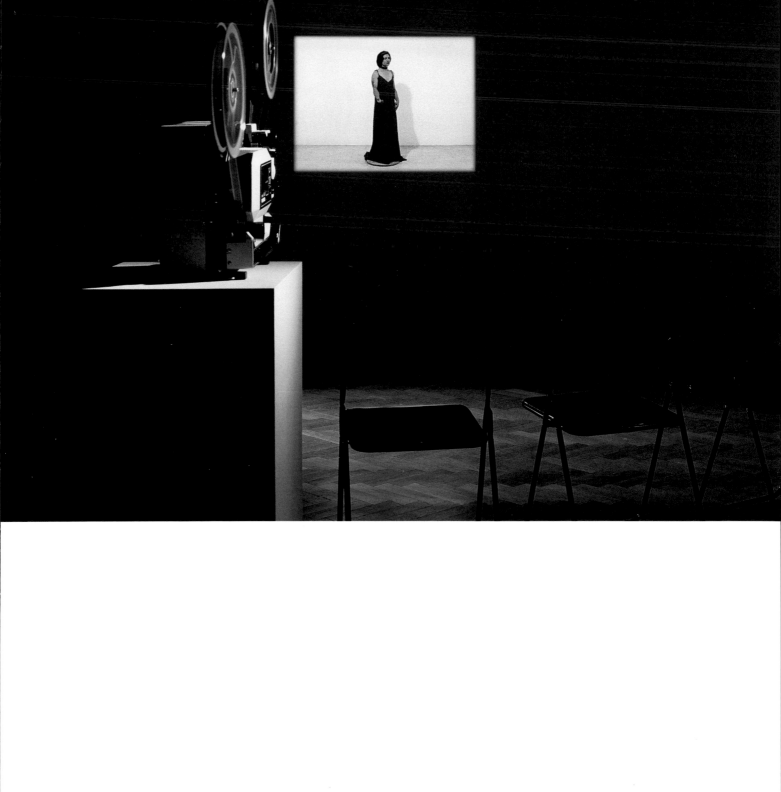

Amar Kanwar

Indian, born 1964

A Season Outside

1997

16mm color film, sound, transferred to digital video (projection); 30 min. loop

Restricted gift of Martin Friedman and Peggy Casey-Friedman; Contemporary Art Discretionary Fund, 2004.481

Amar Kanwar has made over forty films exploring a host of issues ranging from politics and economics to philosophy and art. His distinctive approach is equal parts documentary, transcendental rumination, and visual essay. *A Season Outside*, a subtle and poetic work written and narrated by the unseen artist, reveals the anxiety that surrounds the militarized border between India and Pakistan. Partition, the British government's 1947 division of the Indian subcontinent into two nations—Hindu-majority India and Muslim-majority Pakistan—left millions of people on the wrong side of a border, causing violence that has since escalated into an arms race. Meanwhile, the legacy of Mahatma Gandhi, which was defined by nonviolent resistance to British rule and an attempt to reconcile distinct classes and religions, has been diminished by India's Hindu nationalist movement.

Kanwar's film opens with the sunset ritual of closing the gate on the border at Wagah-Atari, where military personnel engage in displays of nationalistic aggression before crowds of spectators on either side. This staged conflict, which is accompanied by a voiceover in which the artist quietly intimates that violence also occurred in his own family, shows how pervasively physical aggression may infect both cultures and individual human minds. While Kanwar engages in personal reflections, suggesting an evolution in his attitude toward Gandhi's stance of pacifism as intervention, he juxtaposes these with images of enforced division, theatrical military posturing, and real violence: protesters are beaten by police; men cheer as two rams butt and lock horns; an older child pushes a younger one down; birds peck at a stray dog. The artist has said, "There is perhaps no border outpost in the world quite like Wagah . . . an outpost where every evening people are drawn to a thin white line . . . and probably anyone in the eye of a conflict could find themselves here. *A Season Outside* is a personal and philosophical journey through the shadows of past generations, conflicting positions, borders and time zones—a nomad wandering through lines of separation, examining the scars of violence and dreams of hope scattered among communities and nations."[1]

While *A Season Outside* seems to be a documentary, it is presented in an abstract manner more conducive to an aesthetic or emotional effect than to exposé. The film's soulful, elegiac audio track bears a direct but entirely nondidactic, nonjournalistic relationship to its imagery. Kanwar uses his voice to address unflinchingly, in the most personal terms, the human impulse for violence. Yet his visual approaches to the subject are mostly indirect, through metaphorical or reenacted conflict. The work's title denotes a space or time removed from the brutality depicted within, perhaps suggesting the hope that, at some point, there might exist a possibility for peaceful cohabitation, if not reconciliation.

L.D.

Sharon Lockhart

American, born 1964

NO

2003

16mm color film, optical sound; 32:30 min. loop

Restricted gift of C. Bradford Smith and Donald L. Davis; Contemporary Art Discretionary and The Orbit funds, 2004.482

Since the late 1990s, Los Angeles–based artist Sharon Lockhart has become widely known for her visually reductive, rigorously conceptual films. As a student, she was drawn to the work of Chantal Ackerman, Yvonne Rainer, Michael Snow, and Andy Warhol because of the way these artists negotiated the stasis of the photographic image with the narrative flow of cinema.[1] Although candid in appearance, her films slowly reveal themselves to be the result of elaborate preparation and extensive collaboration with her subjects.

Filmed in a continuous take with a fixed-angle camera, *NO* captures Masa and Yoko Ito, a Japanese farming couple, systematically mulching a plot of land. For over half an hour, they arrange tidy piles of straw and then disperse them over a field with minimalist, almost sculptural precision. Lockhart presents, documentary-style, a temporal sequence of events, but the film resists any clear narrative. Viewers share in a sense of discovery by watching the performance, yet they are actually being offered a sort of hyper-reality: the artist creates expectations that do not seem to correspond to the disproportionate attention she has paid to her mundane subject. Lockhart described her process in the following way: "I organized *NO* around the optics of seeing . . . I had the farmers make piles of hay in the reverse perspective of the camera, following the camera's field of vision. . . . After working from background to foreground to make the piles, the farmers come in and slowly spread the hay over just that portion of the field revealed by the camera, from foreground to background, as if they are covering a canvas."[2] As the figures move through horizontal fields of color in a choreographed fashion, Lockhart's film appears almost as a living landscape painting.

This work is inspired by *Nō-no ikebana*, a freestyle form of Japanese flower arranging. The practice is based upon the cycles and rules of agriculture, using fruits and vegetables directly from the farm. As Lockhart has explained, "It highlights a relationship to nature and farming that is somewhat contrary to the overly mechanized large-scale agribusiness prevalent in the United States."[3]

N.R.

Eija-Liisa Ahtila

Finnish, born 1959

Talo/The House

2002

Super 16mm color film transferred to three-channel video (projection, 5:1 surround sound); 14 min. loop

Jointly acquired by The Art Institute of Chicago, Contemporary Art Discretionary Fund and W. L. Mead Endowment; and the Los Angeles Museum of Contemporary Art, purchased with funds provided by the Acquisition and Collection Committee and Bob Tuttle, 2004.483

Culled from research and interviews with individuals suffering from psychotic disorders, Eija-Liisa Ahtila's films are sensual, profoundly moving vignettes. Ahtila's chosen subject matter lends itself easily to perceptual distortions, as series of images flow seamlessly between reality and illusion. Although the rich, epic character studies of filmmakers such as Robert Altman, Ingmar Bergman, and Louis Malle have influenced her work, Ahtila does not attempt to construct or replicate any kind of symbolic order.[1] Instead, she draws viewers into uncanny and deeply fractured environments that suggest the breakdown of human relationships.

Like many artists of her generation, Ahtila situates her practice in between film and video, initially shooting on film and transferring to digital video for exhibition. Her works are rooted in her background as a painter, and she employs color, light, and sound in a vivid, surreal way. *Talo/The House* is a three-channel video installation that envelops viewers, mirroring the protagonist's acts of self-confinement. The film opens with a woman driving up to a secluded house in the woods. Through a series of fixed camera angles that recall surveillance-camera footage in their passivity and fragmentation, Ahtila describes the interior of the house and its surroundings in vibrant, contrasting colors and lush images. As the film progresses, the protagonist hears voices, her awareness of her environment beginning to disintegrate. She describes her experience to the viewer, stating, "Everything is now simultaneous, here, being. Nothing happens before or after. Things don't have causes. Things that occur no longer shed light on the past. Time is random and spaces have become overlapping. No place is just one anymore." As the woman's perceptions unravel, the images become increasingly dreamlike, eventually creating a complete rupture of spatial and temporal boundaries. In one scene, she floats slowly through the trees outside her home, gently brushing against the branches; in another, her car drives around the walls of her house. At varying intervals, she turns to face the camera, confiding in the viewer directly.

In an effort to isolate the splintering images and sounds, the woman sews dark curtains and covers the windows. The screens go dark as she states, "When I don't see anything, I'm where the sounds are. In the street, on the shore, in the ship." As the work reaches its conclusion, the protagonist is enveloped in the shadow and solitude of her home, the tension occurring onscreen reflecting the claustrophobia of the darkened exhibition space.

K.M.B.

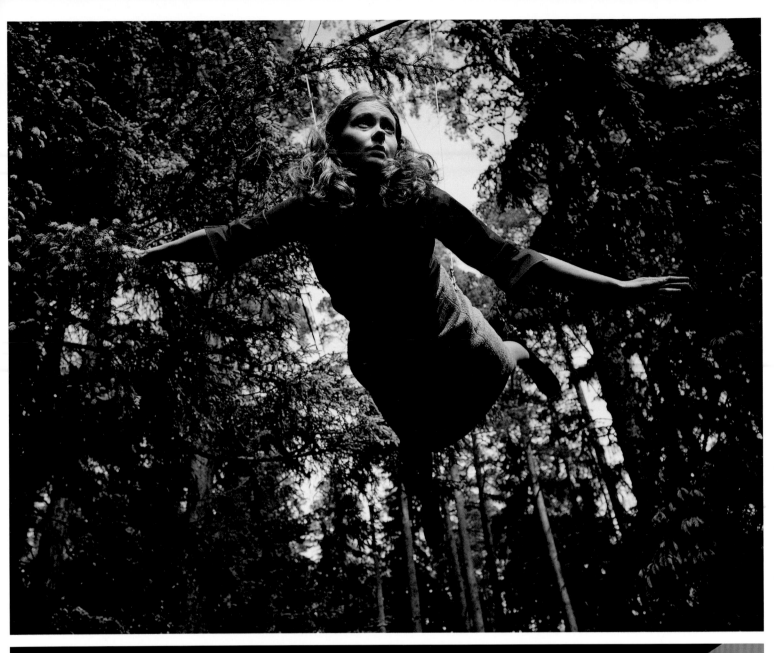

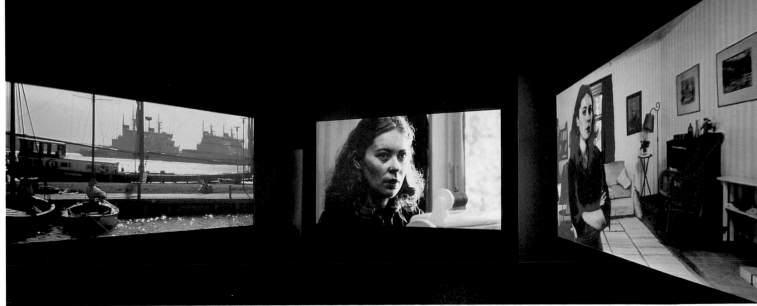

Salla Tykkä

Finnish, born 1973

Lasso

2000

35mm color film, stereo sound, transferred to digital video (projection); 3:48 min. loop

Restricted gifts of Stephanie Skestos Gabriele and Dirk Denison, 2005.21

Although the characters and experiences that Salla Tykkä represents are fictionalized, her practice may be understood as self-portraiture. At the same time, the films in her *Cave* trilogy (2002–03), *Lasso*, *Thriller*, and *Cave*, skillfully distill cinematic genres such as the horror film or the western, drawing out social themes. Tykkä has commented, "In *Lasso*, I approached westerns, which I adored in my youth, their black-and-white set of values reminding me of the society I lived in. I was touched by the questions these films raised about power and by what kind of roles women played in these films and how."[1]

Lasso explores the passage from childhood to adulthood with a grand sensibility. The video begins as a jogger returns from a run in the suburbs of Helsinki, catching her breath as she approaches a front door. Ringing the bell and trying the locked door, she walks around to the back of the house, where she comes upon a series of full-length windows. At first, her reflection is seen in the pane, but as she approaches to peer through the Venetian blinds, the camera reveals the interior of the house. A young man, stripped to the waist and barefoot, is deep in concentration as he swings a lasso. The camera eventually returns to the woman, her eyes and tear-stained cheeks visible through the slats of the blinds.

The music for *Lasso*, equal parts poignant and farcical, is borrowed from composer Ennio Morricone's *Once Upon a Time in the West* (1969), a selection that equates this classic "spaghetti" western with the faux rodeo antics of Tykkä's male protagonist. Coupled with his graceful movements, the mise-en-scène hypnotically draws viewers into the same trance the female character has fallen under. This spell is broken when the young man falls to his knees and forcefully crashes the lasso against the floor, at which point the jogger backs slowly away from the window, leaving behind a trace of her breath on the glass.

According to Tykkä, the original script for *Lasso* was "a story about a young woman in whose everyday life subconscious visions intrude, shattering her reality into pieces."[2] The film focuses on what is seemingly a fragment of a much larger narrative.

K.M.B.

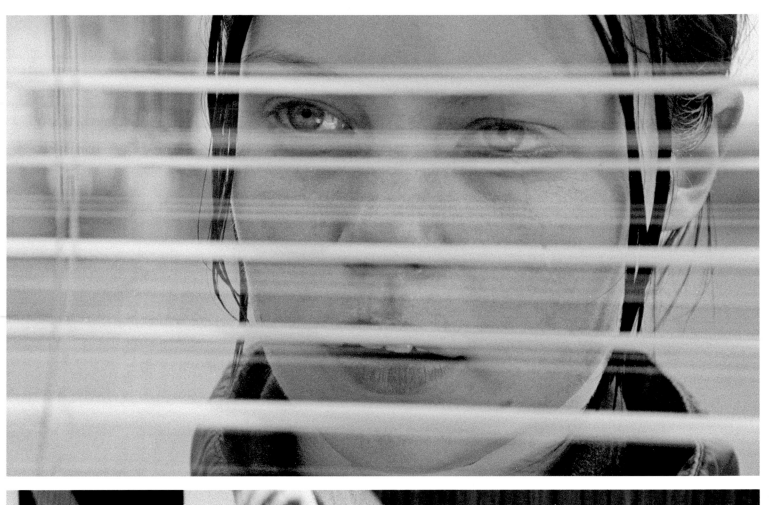

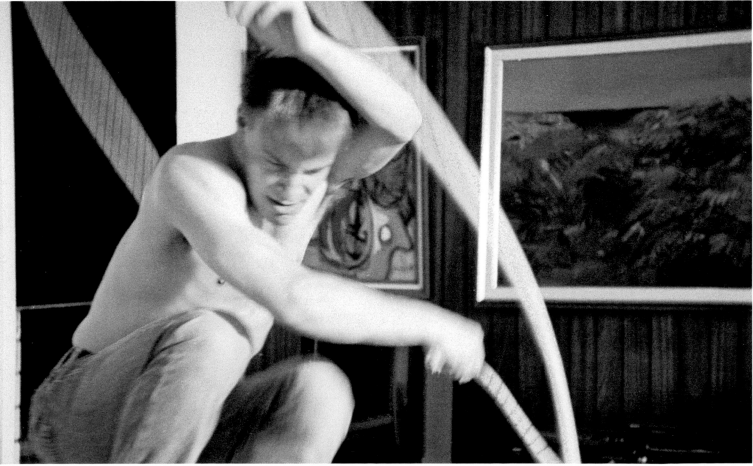

Diana Thater

American, born 1962

Delphine

1999

Five-channel digital color video, sound (projection) with nine-monitor video cube, light filters, and existing architecture; continuous loop

Donna and Howard Stone New Media Fund, 2005.93

Delphine is a landmark work of light projection, a moving-image and color environment created by California-based artist Diana Thater. Widely recognized as a pioneer of video art as installation, Thater is best known for work featuring images of animals (bees, horses, wolves) that have been described as "models of other subjectivities."[1] Thater has stated, "I think about nature and sculpt with images of space. I ask questions about reconstructing subjectivity, using nature and sometimes animals as my models."[2] In *Delphine*, which takes as its primary subject matter wild dolphins interacting with humans, the artist worked for the very first time with untrained animals in their natural habitat. Thater chose dolphins because, as she put it, "I wanted to work with fluidity and sometimes the simplest solutions are the most obvious."[3]

Complex spatial thinking is key to Thater's project; she understands video installation as a dialogue between sculpture and architecture. Projected on a large scale——onto entire ceilings, walls, and floors—her work thoroughly transforms the physical realities and architectural idiosyncrasies of the spaces it inhabits. This generic and spatial fluidity also blurs conventional boundaries between the work and the viewer.

The artist also insists on revealing, through the construction of her works themselves, how images are made and the conditions in which they are presented. *Delphine*, for instance, was shot with four pieces of equipment simultaneously: scuba divers held two digital video cameras, and two Super 8 cameras were used by crew members wearing only snorkel gear. Thus the shots from the bottom looking up are all on video, and the shots from the top looking down are all on film. These were intercut without regard for separating the different media; film and video are both visible. Clarity and atmosphere, grain and line flow into one another, and the perceived immediacy and flatness of video and the perceived memory and depth of film give way to and mutually reinforce or deconstruct one another. These self-conscious production methods are mirrored by Thater's particular aesthetic of presentation: she always leaves the equipment in full view inside the installation. This transparent approach, the artist insisted, "does not, as some people might have us believe, preclude transcendence. This is ultimately my point—that neither magic or superficial beauty is required to approach the sublime."[4]

J.R.

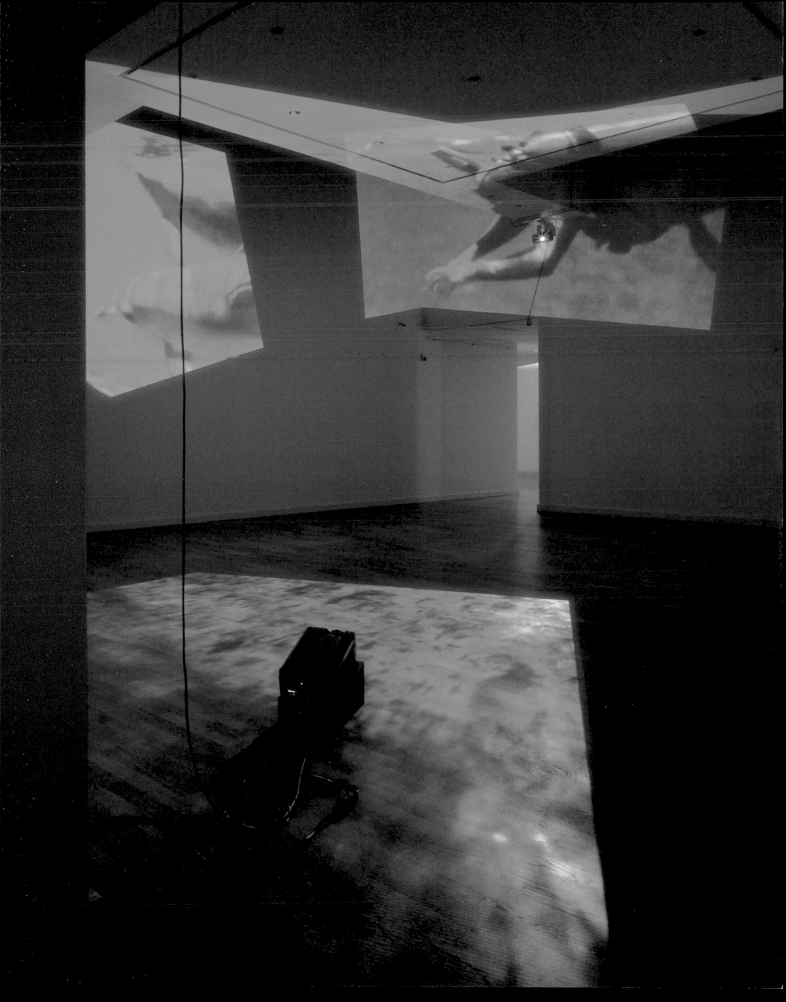

Rodney Graham

Canadian, born 1949

Torqued Chandelier Release

2005

35mm color film, silent (custom film projector at 48 fps); 5 min. loop

Major Acquisitions Fund, 2005.292

Vancouver-based Rodney Graham has adopted a variety of roles as an artist—musician, performer, philosopher, scientist, and writer—but he has been primarily recognized for his moving-image installations in varying formats of film and video. A nimble and rigorous reinvestigation of 1970s Conceptualism, Graham's oeuvre has led him to be described as an artist who works on "multiple tracks" rather than in sequential stages.[1]

Torqued Chandelier Release is the third—and most ambitious—of a trio of films that the artist described as "illustrated 'thought experiments' documenting transitory lighting events within the context of a single roll of film."[2] Inspired by Sir Isaac Newton's famous water-bucket experiment, which explored the nature of rotational motion, *Torqued Chandelier Release* documents a crystal chandelier—wound up on a rope off-camera and then released—spinning in one direction until the rope unwinds, slowing, then spinning in the reverse direction, and so on, until finally coming to rest.

The film was shot at twice the normal speed with a 35mm camera placed on its side, and is shown in a vertical format through a custom-built, high-speed projector. The image of the spinning chandelier becomes hypnotic—it takes on a sculptural, three-dimensional appearance that is unlike anything made by conventional filmic means; the intensified resolution and lush texture transform the simple event into a dizzying, glamorous spectacle. As Christina Bagatavicius has explained, however, all this glitter is used to make a historical and intellectual point as well: "The luminosity of the chandelier also takes on a richer meaning when related back to Newton's status as a central thinker during the age of Enlightenment. Within this context, the chandelier takes on the dual role of recreating a historical experiment as well as cleverly personifying the illumination of the mind through thought."[3]

Graham's deadpan humor permeates his work. Here, he chose the image of the chandelier from his memory of an incident in the 1952 film *Scaramouche*, in which the lead character is nearly impaled by a falling chandelier (yet another Newtonian lesson) and escapes his enemies in the guise of a Commedia dell'Arte buffoon. Likewise, Graham often conceals his own identity—in this case, as an artist-cum-experimental scientist—as a means of subverting the authorship, originality, and identity issues that have been at the forefront of contemporary art discourse for the last two decades.

N.R.

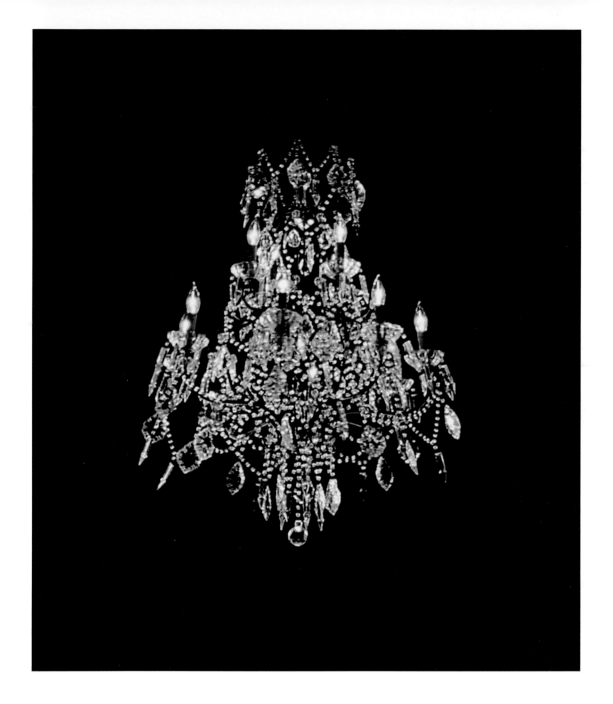

David Hammons

American, born 1943

Phat Free

1995/99

Color video, sound, transferred to digital video
(projection, surround sound); 5:20 min loop

Through prior gifts of Mary and Leigh Block and
Florence S. McCormick; Robert and Marlene
Baumgarten Endowment; and anonymous gift,
2005.294

Working with the detritus of African American life, David Hammons addresses black history, African culture, racism, and poverty with a compassion and complexity unrivaled in contemporary practice. With cunning wordplay and biting sarcasm, he transforms found objects often culled from the streets of New York—these include basketball hoops, chicken wings, dirt, and dreadlock clippings—into powerful symbols that challenge stereotypes and confront issues of race. Street culture provides the artist not only with source material but also with a primary audience: Hammons often creates installations and stages performances on corners and vacant lots, notoriously shunning most of the art world's galleries and museums. The artist has said, "I think I spend 85 percent of my time on the streets as opposed to in the studio. So when I go to the studio, I expect to regurgitate these experiences of the street. All of the things that I see socially—the social conditions of racism—come out like a sweat."[1]

Phat Free begins with several minutes of darkness overlaid with an unidentifiable loud, metallic sound. As the video image is revealed, a man—Hammons himself—appears dressed in a long coat, felt hat, and sneakers, kicking a metal bucket down a deserted city sidewalk late at night. The work was shot in 1995 to document Hammons's late-night performance and edited into an independent video work four years later. At first seemingly violent, the noise evolves into an almost musical rhythm that is synchronized with the protagonist's methodical movements. The title elaborates this musical allusion, conjuring both the streetwise lyricism of rap and hip-hop and the improvisational nature of jazz.

The video's rough, grainy texture communicates the harsh reality of life on the streets and also evokes the early performance videos of Vito Acconci (see pp. 66–67), Bruce Nauman (see pp. 18–21), and others. In and of itself, the action of kicking the bucket suggests the man's potentially unfortunate fate. At once jarring and poetic, Hammons's simple gesture becomes an act of symphonic proportion, a compelling metaphor for one kind of contemporary black urban experience.

L.D.

Nan Goldin

American, born 1953

The Ballad of Sexual Dependency

1979–2001

35mm color slide installation (720 slides with programmed soundtrack); 43 min. loop

Through prior bequest of Marguerita S. Ritman; restricted gift of Dorie Sternberg, the Photography Associates, Mary L. and Leigh B. Block Endowment, Robert and Joan Feitler, Anstiss and Ronald Krueck, Karen and Jim Frank, Martin and Danielle Zimmerman, 2006.158

Since the early 1970s, it has been Nan Goldin's obsession to record an experience positioned decidedly on the margins of conventional society, and *The Ballad of Sexual Dependency* represents the zenith of this endeavor. A hybrid of photography and moving-image installation art, the work comprises over seven hundred of Goldin's photographs, which are projected in thematic arrangements representing gender roles, love, dependency, and alienation, and paired with evocative songs such as the Velvet Underground's "Femme Fatale" (1972), "I Put a Spell on You" (1956) by Screaming Jay Hawkins, and Dean Martin's 1955 "Memories Are Made of This."

Originally, the slide projector was created to be cheap, portable, and user friendly, since it was targeted to amateur photographers and families, and meant for use as a pedagogical tool in schools and industries. The adoption of this technology as an artistic vehicle, which emerged from the Conceptual and experimental film and video movements of the 1960s and 1970s, was centered in public, performance-based work.[1] As the medium began to enjoy a growing presence in the art world, *The Ballad* took shape as a self-contained piece with a dedicated soundtrack, codifying earlier, more performative presentations of the work in the clubs and cinemas of New York's artistic demimonde. Continuing to embrace the humble analog quality of the slide show format was an important aesthetic and artistic decision on the part of the artist, who now has at her disposal an array of more technologically advanced methods of multi-image display.

Goldin's installation offers up a more exposed and potentially more honest version of the garden-variety domestic slide show ritual, capturing the very sort of subjects and events that are considered outside normative notions of identity, relationships, and community.[2] Viewers see the artist, her friends, and family in experiences of the utmost intimacy—lovemaking, violence, addiction, hospitalization—and witness the rollercoaster of emotions that accompany them.[3] Goldin's basic strategy of making the private public, however, anticipated the effects of Facebook, MySpace, and other new media that have changed the shape of the average person's experience in ways even she may not have expected.

The Ballad represents the first joint acquisition between the Art Institute's departments of Contemporary Art and Photography, signaling its landmark status not only within Goldin's oeuvre, but also as a slide installation that charted new territory in the history of film, video, new media, and photography.

K.B./L.D.

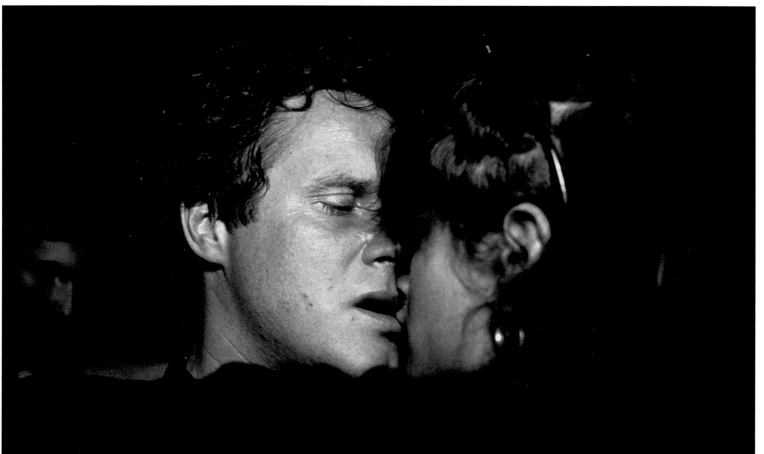

Gordon Matta-Clark

American, 1943–1978

Splitting

1974

Super 8 black-and-white and color film, silent, transferred to 16mm film; 10:50 min.

Restricted gift of Dirk S. Denison, 2006.747

Gordon Matta-Clark is best known for bold, unconventional drawings, films, photographs, and sculptures relating to the built environment. The son of Surrealist painter Roberto Matta, he studied architecture at Cornell University from 1962 to 1968; there, he met sculptor Robert Smithson, whose interests in land art and the theory of entropy influenced him significantly. After completing his studies, he moved to New York and became a well-known figure among artists in the burgeoning avant-garde scene centered in Soho. Matta-Clark's principal contribution was as a radical sculptor: he is recognized for his series of "building cuts" (1972–78), in which he carved out sections of entire structures, treating them as spatial compositions. Calling these transformations "Anarchitecture," the artist documented them in films and photographs that were subsequently exhibited in galleries, often alongside fragments of the buildings themselves.[1]

One of his most celebrated sculptures consisted of a vertical slice into an old frame house located in Englewood, New Jersey. The home, owned by New York art dealer Holly Solomon, was slated for demolition. The resulting film is composed of intentionally artless footage showing Matta-Clark and his friends making two parallel cuts down the center of the house; jacking up one half of the structure and beveling the cinderblock supporting it; and then lowering that half back down, bisecting the home and creating an ephemeral display of light inside the once-compartmentalized interior. The movie's documentary style is the result of the artist's dramatically physical approach to filmmaking. It reveals Matta-Clark as a daredevil, climbing around a structure that has nothing but a few jacks preventing it from collapse. The sequences, which study the light effects produced by the building cut, reveal a domestic space transformed into a sundial on a grand scale.

After he created *Splitting*, Matta-Clark invited select members of the art community to travel by bus to the home and see it firsthand, an act that was not without some physical risk to the out-of-place gallery-goers. Three months later, the house was leveled. While the majority of the artist's projects were only meant to exist temporarily, films such as *Splitting* preserve the ephemeral nature of his approach and also remain as important works of art in their own right.[2] Indeed, *Splitting* has been remembered as "one of the premier moments of a period in which anarchistic, architecturally oriented sculpture coexisted with Conceptual art."[3] During his short career—he died of cancer at age thirty-five—Matta-Clark made over twenty films documenting his architectural explorations and interventions; these have become an extremely important influence for contemporary artists such as Matthew Barney, Pierre Huyghe (see pp. 68–69), and Rachel Whiteread.

N.R.

Vito Acconci

American, born 1940

Centers

1971

Black-and-white video, sound; 22:43 min.
New Media Art Study Collection, Obj. 189060

John Baldessari

American, born 1931

Baldessari Sings LeWitt

1972

Black-and-white video, sound; 12:50 min. loop
New Media Art Study Collection, Obj. 189072

Dara Birnbaum

American, born 1946

Technology/Transformation: Wonder Woman

1978–79

Color video, sound; 7 min. loop
New Media Art Study Collection, Obj. 189065

These works by Vito Acconci, John Baldessari, and Dara Birnbaum date to the early days of video art. All three were made in the 1970s—a time of significant change for the medium—and exemplify important aspects of its technological and conceptual evolution.[1] Video art embraced all of the disciplines prevalent during the decade—sculpture, language, and especially performance—but also quickly emerged as its own field. Within its parameters, artists could explore the intimate relationship between performer and audience in the context of real time.

In *Centers* (at top), Acconci's finger wags slightly as he tries to hold still, pointing at himself, the camera, and the viewer. He wears a look of confrontation: as he stares intently outward, we look back, forming an uneasy connection. In *Baldessari Sings LeWitt* (at middle), the artist enters the frame, sits in a chair, and speaks in a conversational tone to his audience. Like Acconci, Baldessari serves as the subject of his own work as he sings Sol LeWitt's "35 Sentences on Conceptual Art" (1969) to familiar tunes. By using their own bodies, the artists engender a human closeness with the viewer. Birnbaum's *Technology/Transformation* (at bottom) is a little different in this regard, as she chose to feature not herself, but an appropriated image of Wonder Woman, who spins endlessly in the video. But the work rightly assumes that the audience is already familiar with Wonder Woman as a pop-culture icon, so in some sense intimacy already exists.

This closeness between performer and viewer is heightened by the passing of time. Acconci confronts his audience for over twenty minutes, testing both their endurance and his own in an increasingly intense and meaningful way. While Baldessari delivers his songs, viewers have the chance to adjust to their initial surprise at his playful delivery of high-art Conceptualism and develop questions about LeWitt's rules and the very definitions of art. Birnbaum cuts and repeats the image of a spinning Wonder Woman into easily consumed chunks of time; the constant pop that signals her transformation creates a staccato soundtrack. The audience witnesses her change over and over again, which perhaps reinforces the underlying impression that an ordinary woman must metamorphose into a superhero in order to succeed. In different ways, all three artists create the opportunity for viewers to challenge both the way they perceive art and relate to its makers.

A.S.

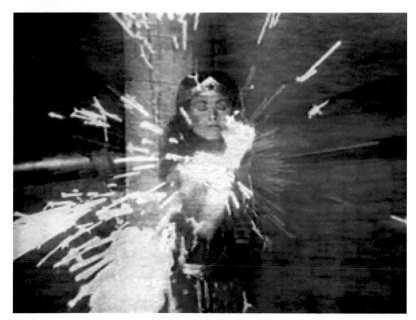

Pierre Huyghe

French, born 1962

Les Grands Ensembles (The Housing Projects)

1994/2001

VistaVision film, sound, transferred to digital
video (projection on screen;) 7:51 min. loop

Gift of Donna and Howard Stone, 2007.31

Noted artist Pierre Huyghe uses diverse media—including large-scale installation, public events, and video—to delve into the uncertainties of representation and to investigate how narrative models affect our sense of reality. In the process, he moves through a variety of creative fields, such as architecture, cinema, design, and music, with an eye to their unique qualities and conventions. Although often grounded in particular historical or cultural reference points, his works unfold as open-ended entities that invite multiple interpretations.

Huyghe's video installation *Les Grands Ensembles (The Housing Projects)* presents a fixed view of two residential towers in a bleak urban landscape, swathed in fog at night. Lacking any signs of human activity, the buildings appear to take on lives of their own as the video's buzzing electronic soundtrack, composed by Pan Sonic and Cédric Pigot, builds in intensity. Windows in the two facades begin to light up rhythmically and with increasing frequency, as if communicating in some sort of code. The towers, which are actually models the artist created in a film studio, echo French government housing projects common in the 1970s, but they do not represent specific buildings. Instead, they can be seen as archetypes, standing in for the Modernist program in architecture and the social agendas to which it was tied. Meanwhile, the audio track is reminiscent of experimental directions in electronic music in the same era, reinforcing this historical allusion. The video is a reflection on the failures of utopian Modernism, signaled in part by the desolate mise-en-scène. This familiar narrative, however, ultimately gives way to the volley of lights, a mysterious cipher that resists attempts at interpretation.

A landmark project for Huyghe, *Les Grands Ensembles* premiered at the 2001 Venice Biennale as part of the artist's installation of the French Pavilion. There it was accompanied by other works, such as *Atari Light* (1999), a room-sized version of the early video game Pong, which visitors could play on illuminated ceiling panels that evoked a Modernist grid. Huyghe installed the works in multiple rooms, separated by doors with modulating levels of transparency, to create what he described as "a blinking organism"—a constellation of associations and disjunctions that shifted as lines of sight opened up and disappeared.[1]

Interweaving themes from the histories of architecture, design, and popular culture, Huyghe invites viewers to consider our relationship with the overdetermined, highly coded world of mass-media representations. *Les Grands Ensembles*, for its part, introduces the artist's engagement with forms of spectacle and the cultural conditions that emerge from them. The flashing lights that play across the facades of these buildings, repeated in an endless video loop, seem to ask whether this is a stream of coded information waiting to be translated or a deluge of vacant representation, a spectacle pointing to nothing but itself.

K.L.

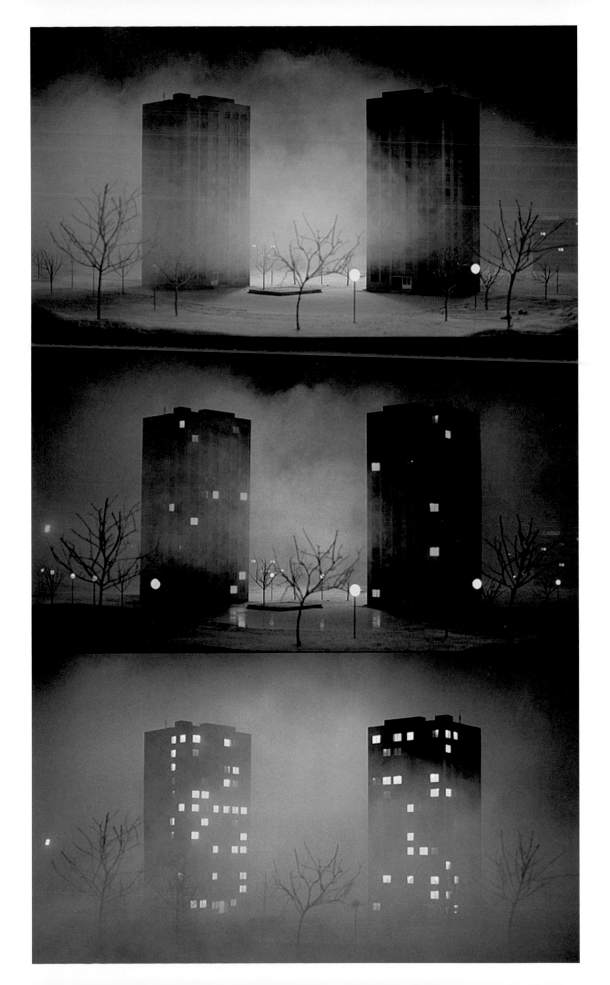

Darren Almond

English, born 1971

Schwebebahn

1995

8mm black-and-white and color film, sound,
transferred to digital video (projection);
12 min. loop

Gift of Donna and Howard Stone, 2007.32

In his films, live video connections, and kinetic sculptures, Darren Almond investigates the themes of time, space, and endurance. Growing up in the working-class town of Wigan, near Manchester in northern England, the artist spent much of his leisure time as a train-spotter; this enthusiasm has motivated his exploration of time structures and transportation systems—clocks and trains appear often in his work. Not unlike the physicist Albert Einstein, who coincidentally used the example of a clock on a train to explain the space-time continuum, Almond explores the ways in which these seemingly fixed factors are in fact reciprocal and relative.[1]

The first of a trilogy of short films based on trains, *Schwebebahn* features one of the oldest, most unusual, and still notably efficient public transportation systems in the world: the suspended monorail system in Wuppertal, Germany, built between 1898 and 1901. Using a handheld Super 8 camera and shooting from several vantage points within the train cars, Almond produced footage that was, as Martin Herbert described it, "Inverted, reversed, and retarded . . . so that the train appeared to be above the rail and the landscape below appeared to be above and upside-down. In slow-motion, the experience of riding the rails. . . became a kind of suspended animation in a parallel universe."[2] In Almond's disorienting world, the viewer's experience of gravity and perception is unbalanced: the horizon is misleading, and time and movement are cyclical, reversed. This defamiliarizing sensation is further heightened by a soundtrack of hypnotic electronic music.

The two other films in the trilogy are *Geisterbahn*, or *Ghost Train* (1999), which documents a shadowy ride through a haunted house in Vienna that was rebuilt after World War II, and *In the Between* (2006), a three-screen projective installation that follows the recently opened railway from Xining, China, to Lhasa, Tibet, with symbolic vignettes from each of the once completely isolated areas. Throughout his oeuvre, Almond acknowledges the passing of time and its inevitable consequences, whatever they may be. Without judgment, he creates poetic comparisons between our analog past and the increasing speed of the digital age.

N.R.

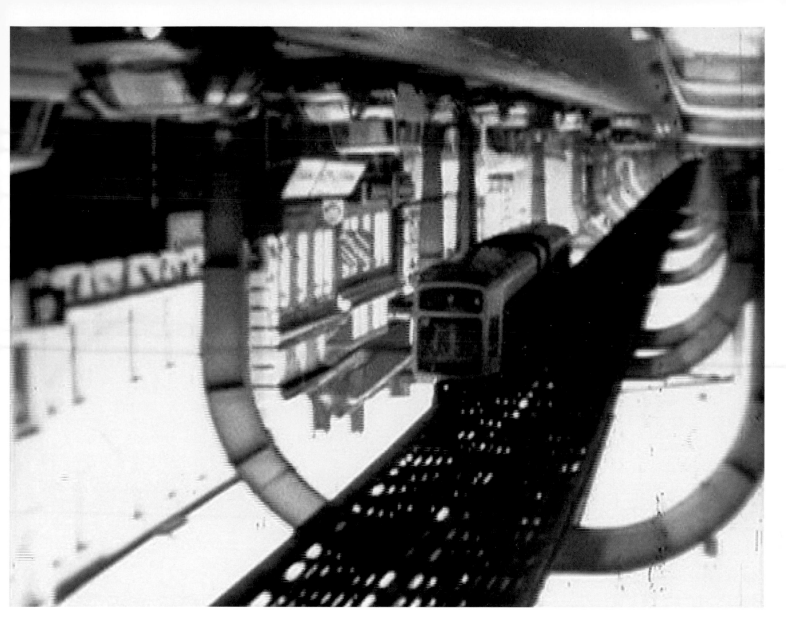

Doug Aitken

American, born 1968

monsoon
1995

Color film, sound, transferred to digital video (monitor or projection); 6:43 min. loop

Gift of Donna and Howard Stone, 2007.33

thaw
2001

Color film, sound, transferred to three-channel digital video (projection on three attached screens); 4:10 min. loop

Gift of Society for Contemporary Art, 2002.79

the moment
2005

Eleven-channel digital video, sound (projected on plasma screens with mirrors); 6:30 min.

Gift of Donna and Howard Stone, 2007.34

Doug Aitken's acclaimed video installations take aim at what it means to live in an age when human experience is increasingly shaped by the mediating effects of technology and an unprecedented degree of mobility. Many of his videos unfold as journeys through desolate places in which the natural and the artificial begin to blend. Others offer technology-inflected visions of landscapes in a state of flux. Aitken described his body of work as a series of "structures which move outward in different trajectories and yet share a connection."[1] He went on to say, "If I create a work which is intensely human, then maybe the next work I want to make is as far from that as possible. It is a constantly evolving process of point and counterpoint." The three works by Aitken in the Art Institute's collection—*monsoon*, *thaw*, and *the moment*—vary in their formal qualities and subject matter, but they all pursue similar themes. Additionally, they provide a sense of how Aitken has used the spatial configurations of his multichannel installations in increasingly ambitious ways to extend his films' narratives beyond the edges of the screen.

One of the artist's most understated and formally restrained works is *monsoon* (opposite, at top), an early single-channel video. In 1995, Aitken traveled to Jonestown, Guyana, where almost twenty years earlier nearly one thousand members of the People's Temple joined their leader, the Reverend Jim Jones, in a mass suicide. The artist had no other goal than to wait for a looming monsoon to break, and in the video the camera stands in as a patient witness, panning slowly across the ominously still landscape. Vibrantly colored views of the jungle, verging toward abstraction, are juxtaposed with vestiges of human presence, such as a barren road and an abandoned truck. The only sounds are a low drone and the occasional chirping of birds and crickets. The wind starts to blow heavily as night falls, but the rain never arrives. This potential moment of catharsis is deferred, and the viewer is left to contend with a sense of anticipation and absence, searching the landscape for telling traces of its past as the camera carries out its impassive surveillance.

Another of Aitken's voyages—in this case to a glacier in Alaska—inspired *thaw*, which depicts a landscape that is austere and seemingly free from the touch of human history. In this three-channel projection, expansive views of moving clouds and bright sun give way to images of melting snow and sheets of ice breaking off into the exposed sea. Perhaps first and foremost, *thaw* (at bottom) is an overtly sensual experience, filtered through and heightened by technology. At times, the images on the angled, adjoining screens merge to create an expansive panorama, while at other moments Aitken inverts an image to produce a disorienting effect or introduces an unexpected sensation of rhythm by juxtaposing close-ups of cracking ice or water droplets. Meanwhile, the layered, pulsing audio track contributes to a sense of volatility and movement, amplifying the quality of technological mediation as one views the glacial landscape. For the audio, the artist recorded ambient noises on location and later combined them with additional sounds that he synthesized electronically. Presenting a fractured, kinetic portrait of this place, he conveys through largely formal means the hidden dynamism of the arctic terrain as it shifts between solid and liquid states.

If Aitken's projects often describe how technology shapes our relation to place and our ways of being in the world, in a more abstract manner the artist explores how technology and motion can inform our notions of space and time. In a brief but prescient passage in a 1950 essay, the philosopher Martin Heidegger described how developments in the technology of media (film, radio, and television) and transportation (the railroad and the automobile) gave rise to a condition of uniform "distancelessness" in which "everything is equally far and equally near."[2] Aitken's art seems to focus on these cultural conditions in an advanced state, more than forty years later. He has remarked, "On some level, all of my work is related to what I see as certain new tendencies in the culture . . . Accelerated nomadicism, self-contained, decentralized communication—these things are at the core of the space we're living in, a terrain that is radically different from the past."[3]

Of all his works, Aitken's large-scale video installation *the moment* (opposite) perhaps deals with these ideas most explicitly. The installation consists of eleven screens suspended from the ceiling in an S-pattern and, as the video begins, the darkened gallery resounds with a hushed whisper that declares "I want to be every place." The piece then presents a tightly orchestrated sequence of views that show people waking up in hotel rooms or nondescript dwellings and moving out into largely deserted cities. As the fragmented narrative progresses, anonymous characters engage in similar sets of activities, which emphasizes a common state of being—an urge to get moving, to be everywhere—if also a degree of isolation.

The configuration of *the moment* continues the themes of movement and unrest while providing a figurative parallel between human travels and the flow of images around and to us. The visitor to Aitken's installation navigates a dark, wide-open gallery space to view the work, prompting a state of wandering that recalls that of the film's subjects. Depending on where one stands, the visual relationship between the different screens changes, and each monitor has a mirror on its back, which expands the visual field dramatically and creates a kaleidoscopic flurry of imagery in certain viewing positions. At the same time, the channels are not static—the narrative threads do not play on set monitors but instead migrate across the eleven screens in different ways as the video progresses. For much of its duration, variations of similar scenes play across the screens simultaneously, enacted by different characters; occasionally, however, a single image aligns momentarily on all of them. Finally, the images are set into a frantic state of motion, jumping from one screen to the next in quick succession. The looped video builds to a rushing climax before starting over—the characters returning, if only temporarily, to a state of rest.

K.L.

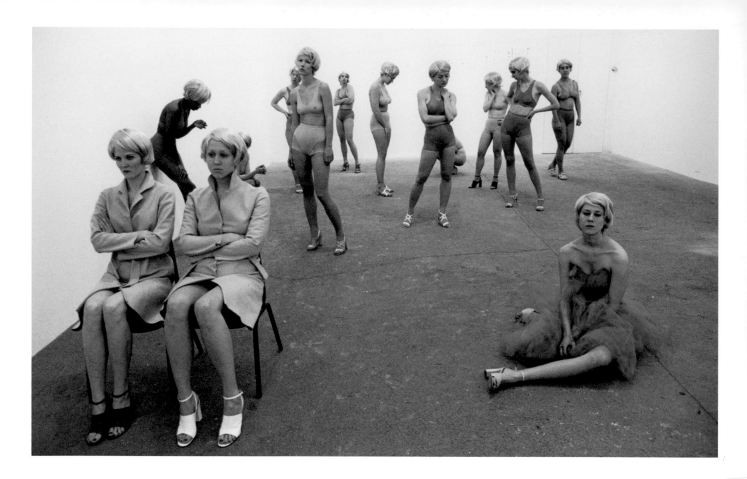

Vanessa Beecroft

Italian, born 1969

Piano Americano

1996

Color video, sound (projection); 30 min. loop

Gift of Donna and Howard Stone, 2007.35

Vanessa Beecroft stages *tableaux vivants* of nude or seminude women, whom she arranges in loose configurations according to predetermined rules. Her works center on these public performances but often culminate in photographs or videos. Beecroft blurs the boundary between art and fashion to the point that, in recent years, eminent designers have provided the attire for her models. Adopting the fashion industry's use of sex as a sales tool and openly presenting women as a silent visual spectacle, she engages with structures of power and economies of desire while provocatively toying with cultural expectations of female sexuality.

In *Piano Americano*, two women in beige trench coats sit decorously in chairs, facing the camera, while to their left a woman in a bright green party dress sprawls on the floor. Behind them, nine women in flesh-colored underwear mill around, looking aloof or bored, occasionally squatting down or running their hands along the wall. Over the course of half an hour, the camera slowly pans across the different groupings of women. Eventually it begins to zoom in on their faces and their bodies, both enacting and eliciting the viewer's lingering gaze. Beecroft's work partakes in the voyeuristic dynamics of sexual consumerism with a degree of self-conscious complicity, but she also denaturalizes these patterns and invites the viewer's discomfort. Beecroft has said, "I like to display nudity to provoke the fear or embarrassment or the confusion of the audience."[1] Poised between eroticism and cool, structured formalism, her living displays are suggestive but emotionally vacant, demonstrating an aloof yet potentially aggressive sexuality.

K.L.

Jeanne Dunning

American, born 1960

Icing
1996

Color video, sound (projection); 30 min. loop

Gift of Donna and Howard Stone, 2007.36

Since the late 1980s, Chicago-based artist Jeanne Dunning has become known internationally for her provocative photographs and videos that employ the human body to explore gender norms, sexuality, and our visual apprehension of reality.[1] In many of her works, she initially fosters moments of misrecognition, leading us to think that we are looking at something other than what is actually represented. The artist also often develops a degree of tension between the grotesque on the one hand and the sensual or erotic on the other.

In the video *Icing*, the hands of an anonymous, off-screen woman are shown as she prepares a bowl of white cake frosting. Slowly, over the course of thirty minutes, she uses it to cover the head of another woman, as if decorating a cake. This cool, methodical process depersonalizes the seated woman, gradually obscuring her features. In the end, the sitter loses her individual identity, becoming instead an inert sculptural form vaguely reminiscent of a marble bust, which is accentuated by a white paper collar around the neck that effectively serves as its base. Meanwhile, the actions of the faceless pastry chef resemble the strokes of a brush or palette knife, evoking the act of painting.

Notably, these allusions to classical art forms emerge through activities and materials that traditionally carry feminine, household associations, which are underscored at the end of the video as the woman washes her utensils. In this regard, Dunning's work recalls feminist video art of the 1970s, which depicted homely activities with a sustained, concentrated focus, aiming to legitimize the place of the domestic in art. The nature of the interaction in *Icing* complicates this kind of practice, however, by suggesting that a fixation on supposed women's routines can be potentially restrictive or fetishizing—not unequivocally liberating.

K.L.

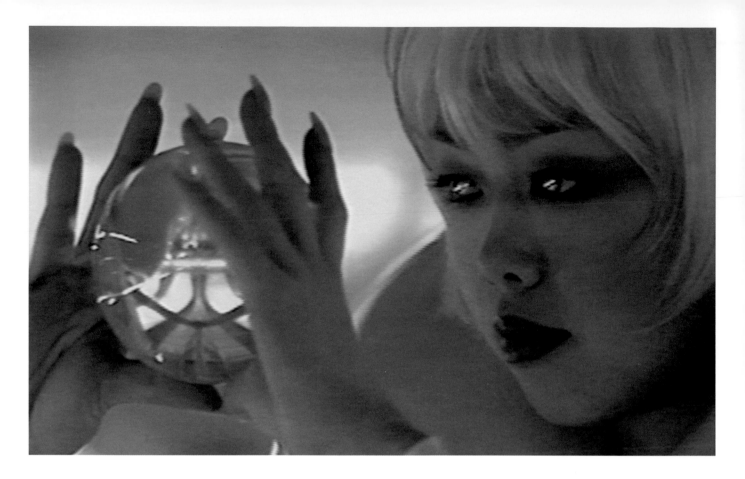

Mariko Mori

Japanese, born 1967

Miko No Inori

1996

Color video with capsule and crystal; 29:23 min.

Gift of Donna and Howard Stone, 2007.37

Working with a studio of designers and technicians, Mariko Mori uses sophisticated technology to realize ambitious productions in diverse media including video, large-scale photography, and 3-D imaging. Turning to fashion, pop culture, and science fiction as aesthetic templates, she creates high-gloss digital dreamscapes that refer to Buddhist thought and religious iconography while presenting an optimistic vision of a technological future. Melding Eastern and Western forms and mixing transcendental themes with open appeals to visual pleasure, the artist proposes a cultural condition in which aesthetics, spirituality, and technology intermingle.

Miko No Inori, which translates as the Shaman-Girl's Prayer, is set in a digitally transformed version of Osaka's international airport, which seems to be at once a vaulted temple and a sleek, futuristic space. As in many of her videos, Mori appears as a cyborg—a fantasy woman, half-machine, half-human—in this instance, dressed in a white, iridescent costume that complements her reflective ice blue eyes. She cradles and caresses a glass sphere while a haunting pop song plays. The figure recalls a fortune-teller with her proverbial crystal ball, but she also invites other interpretations that coexist uneasily: she can be seen as a bodhisattva—a spiritual guide who forgoes nirvana out of compassion for those who suffer—but she also resembles a model promoting a new product, gazing directly at the audience with her glass orb seductively in hand.

K.L.

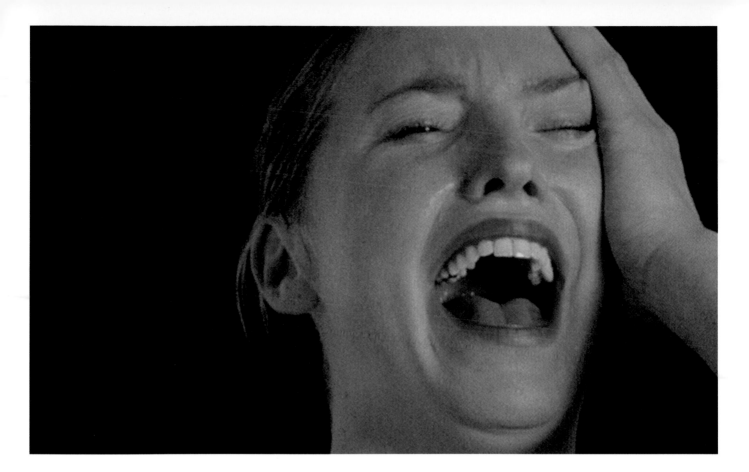

Sam Taylor-Wood

English, born 1967

Hysteria

1997

16mm color film, silent, transferred to digital video (projection); 8 min. loop

Gift of Donna and Howard Stone, 2007.39

Sam Taylor-Wood rose to prominence in the 1990s for her psychologically sensitive films, photographs, and videos. In many of her works, she presents small moments of human drama that function as portraits of individual personalities, passions, and obsessions. The artist has stated, "I am trying to gather a complete series of human feelings, even if reflected in more than one person. The same room is the setting for eroticism, rage, pensiveness, creativity, repulsion, anxiety, joy, anguish, pleasure. It is as if I wanted to explain the entire range of the emotional or existential world."[1] The workings of emotion are far from simple, though, and as Taylor-Wood depicts ritualized expressions and intense outbursts in works like *Hysteria*, she explores the possible disjunctions between outward behavior and an internal sense of self.

The title *Hysteria* refers to an extreme state of emotional disturbance while recalling the now-discredited notion of female hysteria, a common diagnosis during the Victorian era for women experiencing any number of symptoms. The eight-minute video is a closely framed view of a woman's face that challenges us to distinguish whether she is laughing or crying. The footage is presented in slow motion and without sound, heightening the confusion between these different emotions. In narrative cinema, close-ups conventionally elicit a feeling of intimacy with the characters, but Taylor-Wood's ambiguous depiction of the woman's silenced cries encourages varied responses—from conflicting senses of identification and alienation to different shades of emotional engagement and critical detachment.

K.L.

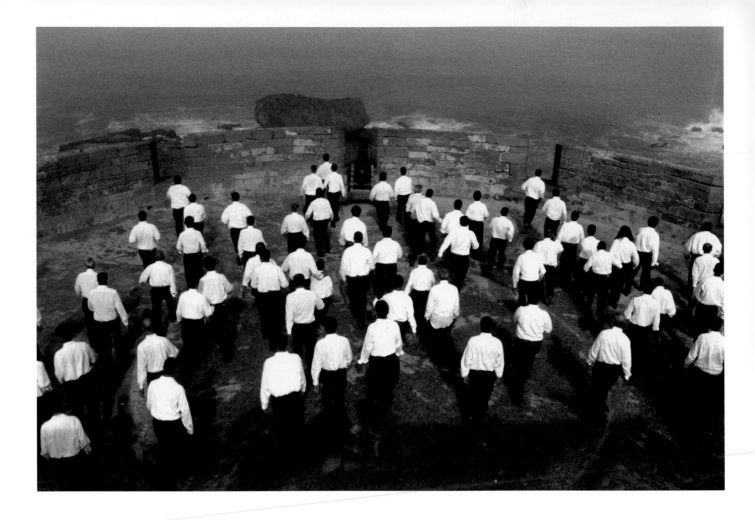

Shirin Neshat

Iranian, born 1957

Rapture

1999

Two-channel black-and-white video, sound
(projection); 13 min. loop

Gift of Donna and Howard Stone, 2007.40

Shirin Neshat's work addresses the social, political, and psychological dimensions of women's experience in contemporary Islamic societies. Because *Rapture* was made prior to the events of September 11, 2001, and the renewed tensions between the United States and the Middle East, current viewers' reactions are informed by associations about Islam and Iran that would likely not have affected perceptions of the work at the time of its 1999 debut in a *focus* exhibition at the Art Institute. *Rapture* is a meditation on the gender politics of Islam. These relationships, embodied by the image of the veiled woman, are often subjected to reductive caricature in the West. Although Neshat actively resists stereotypical representations of Islam, her artistic objectives have not been explicitly polemical. Rather, her work recognizes the complex intellectual and religious forces shaping the identity of Muslim women throughout the world.

Rapture is an installation of two synchronized black-and-white video sequences that are projected on opposite walls; large in scale, they evoke cinema screens. Working with hours of footage and a team of editors, the artist constructed two parallel narratives: on one side of the room, men populate an architectural environment; in the other sequence, women move within a natural one. The piece begins with images of a stone fortress and a hostile desert, respectively. The fortress dissolves into a shot of over one hundred men—uniformly dressed in plain white shirts and black pants—walking quickly through the cobblestone streets of an old city and entering the gates of the fortress. Simultaneously, the desert scene dissolves into a shot of an apparently

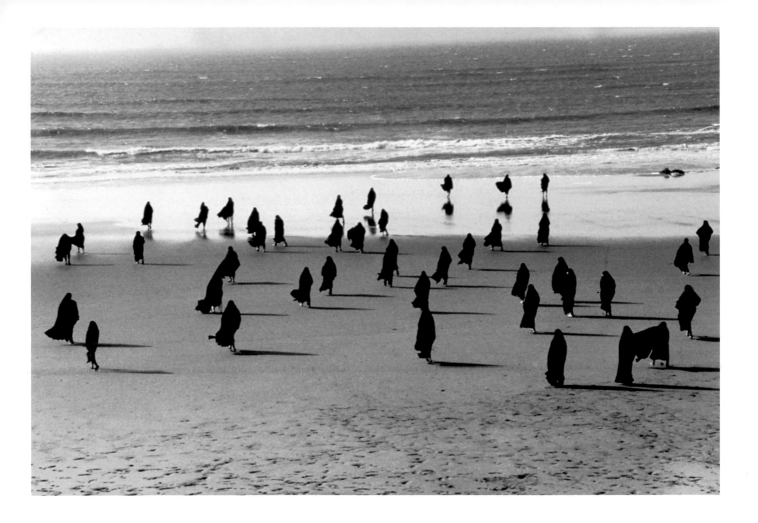

equal number of women, wearing flowing, full-length veils, or chadors, emerging from different points in the barren landscape.

As the video progresses, the men busy themselves with a variety of mundane, sometimes absurd activities that contradict the intended function of the space. On the other side of the installation, the women chant, pray, and later, having made their way across the desert, launch a boat into the sea with six of their own aboard. In *Rapture*, Neshat self-consciously exploits entrenched clichés about gender and space: namely, the equation of woman with irrational, wild nature and man with rational, ordered culture. The video installation is itself a study of gendered group dynamics, with the viewer literally positioned between two opposing worlds. The players in Neshat's surreal, segregated narratives are deployed in a syncopated rhythm of action and nonaction, mutual recognition and nonrecognition, advance and retreat.

Rapture exists as a poignant reflection on the rootless, unsettled psychology of exile. As an Iranian expatriate living in the United States, Neshat maintains a critical distance that has allowed her to locate both the poetics and the power of the veil. At the same time she celebrates the strength and beauty of Islamic women, she remains keenly aware of the horrors of repression.

K.M.B./J.E.R.

Directed by
Isaac Julien

English, born 1960

Choreography and movement material by
Javier De Frutos

Venezuelan, born 1963

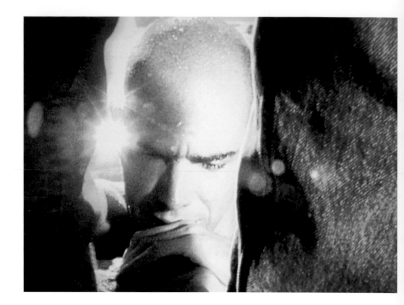

The Long Road to Mazatlán

2000

16mm black-and-white and color film, sound,
transferred to three-channel digital video (rear
projection on screen); 18 min. loop

Gift of Donna and Howard Stone, 2007.41

Isaac Julien creates highly seductive works that investigate the politics of gender, identity, race, and sex in order to engage with, and often subvert, stereotypical representations.[1] Over the course of his thirty-year career, he has shifted his focus from feature-length motion pictures to video and film installations because this format allows him to employ various techniques that help challenge the seamless, linear quality that characterizes mainstream cinema. *The Long Road to Mazatlán* begins with a composite image, reminiscent of CinemaScope, stretching across three screens that are placed side by side.[2] This soon breaks apart to reveal divisions that operate either as separate parts of the same space, revealing multiple perspectives on a single setting or action, or as a composite image composed of misaligned parts. The artist has stated that the use of multiple screens allows him "to explore certain compositional ideas that are impossible with a single screen."[3]

The work's title refers to Tennessee Williams's play *The Glass Menagerie* (1944), in which a family recalls their abandonment by a father who later sends a postcard from Mazatlán, Mexico. Julien explains: "He was going to a place of no return. So Mazatlán is a mythic space."[4] In responding to Williams, Julien conjures the poeticism of the American South. The artist created *The Long Road to Mazatlán* in collaboration with choreographer Javier De Frutos while he was in residence at ArtPace, San Antonio. In the film, two cowboys, played by De Frutos and Phillippe Riera, become entangled in an attraction that unfolds into a tale of lust, longing, and fantasy. Julien uses the settings, costumes, and props of a typical western, although the actions of his protagonists undermine the genre's hypermasculine stereotype. "I'm very interested in seducing audiences into scenarios or tableaux that they might not usually be drawn to or interested in."[5] In this way, Julien's film is informed by—and responds to—the work of artists such as Andy Warhol, whose *Lonesome Cowboys* (1968) explores the sexual politics of the western in a similar fashion.[6]

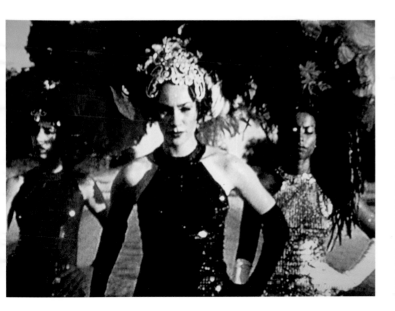

Alternately linear and layered, Julien's narrative shifts between representation and fantasy, showing the characters within a series of richly constructed tableaux including a cattle auction, a saloon, and a swimming pool, their bodies moving in rhythmic relationship. Such vignettes often make reference to art history and popular culture. The surreal colors and interplay between characters in the pool sequence, for instance, seem to take their inspiration from David Hockney's richly colored pool paintings, which capture the relaxed, decadently sun-soaked aspect of gay culture in late-1960s Los Angeles. The most explicit allusion is to Martin Scorcese's *Taxi Driver* (1976), in which Robert DeNiro's character stands before a mirror imagining a confrontation in which he draws a gun and asks, "Are you talking to me?" Underscoring the importance of the gaze, Julien reprises this moment in a motel room, with Riera asking his reflection, "Are you looking at me?"

In the film's closing scenes, which are reminiscent of Stephan Elliot's *Priscilla Queen of the Desert* (1994), the men perform a jerky, deconstructed dance on opposite sides of a road. Three women dressed as showgirls appear in the center, pirouetting as they approach the camera. Julien elaborates: "For me the women symbolically represent a parting from the gender roles that ordinarily would be assigned to them. In the conventional moving-image culture, they would be dancing with the cowboys or be in a position of becoming a vessel for something else. Here they represent a stereotype or hyperbole."[7]

K.M.B.

Hirsch Perlman

American, born 1960

Two Affect Studies

2001

Two color videos, sound (projection);
15 min. loop

Gift of Donna and Howard Stone, 2007.42

Hirsch Perlman, a formerly Chicago-based artist who has lived and worked in Los Angeles since the late 1990s, is known for simple, witty, and self-reflexive photographs and videos. Intensely studio-driven, his work is often created in the spirit of isolated, homespun, nineteenth-century experiments and accidental discoveries. Indeed, in his art, Perlman cultivates the aura and mystery of a mad scientist.

Built upon a narrow conceptual framework, his project revolves around a deliberately limited set of spatial and material choices. One series, for instance, offers a daily chronicle of his three-year-plus retreat into his studio, where he created art only from small incidents and with packing supplies and readily available, found materials. Perlman has called these tragicomic works "low-tech allegories of process . . . stories about what artists do."[1] Ultimately, his charmingly modest pieces reveal themselves as highly sophisticated, self-knowing, and intelligent commentaries on the obsessive aspects of art making. The results speak to the constraints and the freedoms such impulses bring.

Two Affect Studies consists of characteristically simple experiments. In the first sequence, a tape measure marks a spot on the wall while the camera documents the mad, free forms of a rubber band repeatedly snapped into the air. The image is improbably set, to near-comic effect, against "Functional" (1957), a tune by jazz legend Thelonious Monk. In the second part of the work, Perlman recorded the visual effects produced by the billowing wisps of smoke from two cigarettes left smoldering in an ashtray. Accompanied by Samuel Barber's willfully sentimental "Adagio for Strings" (1936), this sequence, like its counterpart, uncovers the surprising potential for emotion, humor—and, ultimately, meaning—that resides within the simplest of stunts.

L.D.

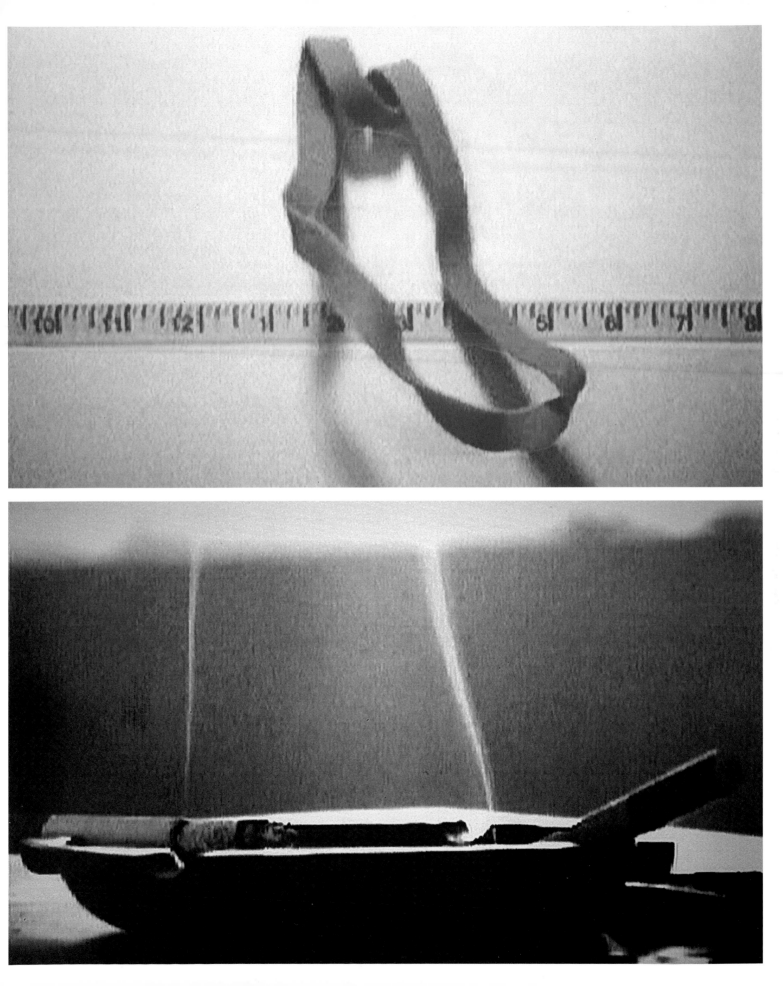

Janine Antoni

Bahamian, born 1964

Touch

2002

Color video, sound (projection); 9:36 min. loop

Gift of Donna and Howard Stone, 2007.43

Since the 1990s, New York–based artist Janine Antoni has established an international reputation with labor-intensive projects in a wide range of media. She incorporates both art history and personal exploration, investigating the ways in which contemporary definitions of aesthetics and art making are connected to issues of gender identity and sexuality. Inspired by the feminist artists of the 1970s, she reframes and subverts art-historical and societal conventions surrounding women and beauty.

Antoni creates intimate, ritualized encounters between her chosen materials and her own body, which has become her essential tool. In *Touch*, which was commissioned for SITE Santa Fe in 2002, she balances on a tightrope, a skill she has sought to master. Here, on the beach in front of her childhood home on Grand Bahama Island, the artist walks a line that is parallel to the horizon. Dressed in sky blue, she enters the landscape from outside the frame. When the wire dips under her weight, it appears to touch the horizon, creating the illusion that she is walking on the water. Like many of Antoni's works, *Touch* records a relationship—a moment of contact—and reveals the artist's longing to bridge the gaps between herself and viewers, between her work and art history.[1]

Antoni begins with an idea of artistic process that dictates the final result and meaning. The idea of *Touch* derives from *Moor* (2001), a work in which the artist created a rope out of her and her friends' belongings; the artist has said that while she intends to walk it, she also questions the impulse.[2] *Touch* depicts a literal balancing act in order to suggest the state of perfection that many people strive for, including herself. Antoni has said, "*Touch* is about that moment or that desire to walk on the horizon," a location that represents hope and the future.[3] She explained that she wants to walk in "this impossible place, a place that cannot be pinpointed . . . on the line of my vision, or along the edge of my imagination."[4] Since the viewer's involvement is a crucial element in her work, Antoni asks us to imagine ourselves in her situation and contemplate the meaning of the horizon when she is absent from the scene. As the artist teeters but never falls, she accepts and almost embraces a state of imbalance.

E.J.

Anri Sala

Albanian, born 1974

Blindfold

2002

Two-channel digital color video, six-channel digital sound (rear projection on two Plexiglas screens; 15 min. loop

Gift of Donna and Howard Stone, 2007.44

Mixed Behaviour

2003

Digital color digital video, sound (projection); 8:17 min. loop

Donna and Howard Stone New Media Fund, 2005.21

Anri Sala has received extraordinary acclaim for a series of unconventionally beautiful, politically inflected videos. A global itinerant, he lives and works all over the world—predominantly in Berlin and formerly in Paris and his native Tirana. The artist's short, formally accomplished works poignantly and strategically blend documentary, narrative, and autobiographical approaches, existing as minimal, abstract allegories of cultural suspension and transition. Concerns of immigration, exile, social alienation, violence, crime, poverty, and repression shadow all of his poetic, melancholic compositions.

Sala's work is rooted in part in Albanian culture and history. He grew up under one of the most repressive communist dictatorships in Europe and later witnessed the tentative transition to a democratic, market-driven system before leaving to study in France in 1996. The following year, the Albanian economy collapsed under the weight of a corrupt government, bringing widespread lawlessness and violent unrest. Sala's intensely analytical perspective has been forged by this firsthand experience of social turbulence and radical change. Confronting a traumatic history while negotiating a diasporic present, his work describes a condition of simultaneous disorientations—temporal, spatial, visual, aural, and linguistic.

Blindfold, like Sala's work in general, displays an acute political consciousness. The two-channel projection (at top) depicts a blinding sun. Shown both at sunrise and sunset, it reflects off a pair of new, as-yet-unused metal billboards in Tirana, a city that figures prominently in many of Sala's mature experiments. The radiant blankness of the two boards, which appear as surrogate cinema screens, suggests the incipient, fragile nature of Albania's transition to a capitalist economy. The infrastructure of shiny public advertising coexists incongruously with the city's decrepit surroundings.

Mixed Behaviour (at bottom) embodies the most important themes and strategies of this artist's oeuvre, including strikingly innovative play between foreground and background, light and dark, sound and picture.[1] Here, a lone disc jockey filmed squarely from behind spins records on a Tirana rooftop. It is a rainy New Year's Eve, and the man bends to his task covered by a plastic tarp while fireworks explode all around him, briefly illuminating the darkness; their clamor overlaps with the sound of gunfire, a local holiday tradition. Gradually, we realize that the video's soundtrack plays in manipulated synchrony with the fireworks: like the Wizard of Oz under a clear plastic veil, the DJ appears to control a scene that stretches across the background like a movie screen or canvas. However, while the music proceeds in a predictable, linear fashion, seeming to conjure the fireworks in the distance, we realize that the images are periodically moving backward; almost undetectably, the fireworks are reversing, seeming to implode. This action suggests the practice of "scratching"—rapidly and repeatedly reversing the direction of a record on a turntable. As *Mixed Behaviour* shows us, Sala exploits the medium of digital video so comfortably and completely that his arrangement of digital image and accompanying sound offers an astonishingly new use of filmic art.

J.R.

Jenny Holzer

American, born 1950

Blue Tilt

2004

Six double-sided vertical LED signs with
Triton blue diodes, stainless steel housings,
and bezels; each 381 x 13.7 x 13.7 cm
(150 x 5 3/8 x 5 3/8 in.)

Restricted anonymous gift; through prior
bequest of Marguerita S. Ritman; through prior
gift of Leo S. Guthman; Watson F. Blair Prize
Fund, 2007.357

Since the 1970s, Jenny Holzer has used language as her medium of choice to communicate penetrating ideas about life and death, sex, power, and war. Like contemporaries including Barbara Kruger, Sherrie Levine, and Cindy Sherman, she appropriates mass media and advertising strategies in her work. Holzer rose to prominence with her *Truisms* series (1977–79), which consisted of nearly three hundred aphorisms and slogans that play on commonly held truths and clichés such as "A lot of professionals are crackpots" and "A man can't know what it is like to be a mother." Displayed as anonymous broadsides on buildings, fences, and walls throughout Manhattan, these statements were meant to provoke public debate. In her more recent work, Holzer continues to use language and current modes of communication to assail established ideas about art's place, audience, and meaning in modern society. Her texts have appeared on benches, billboards, Internet sites, posters, sarcophagi, in the form of monumental Xenon projections, and, most commonly, as LED (light-emitting diode) signs.

Blue Tilt features texts from five of Holzer's iconic series: *Truisms*; *Inflammatory Essays* (1979–82), one hundred words in twenty lines inspired by the literature of Emma Goldman, Rosa Luxembourg, Lenin, Mao, and others, also printed on posters; *Living* (1980–82), matter-of-fact writings on "everyday life with a twist" that were originally shown on cast-bronze plaques and hand-lettered metal signs; the urgent *Survival* (1983–85), which appeared on the Spectacolor board in New York's Times Square and was the first series the artist conceived for electronic signs; and the desperate *Under A Rock* (1986), which was engraved on stone benches shortly after Holzer's move to the countryside of upstate New York.[1] Although all of these texts are the artist's invention, they do not necessarily reflect her personal views. Indeed, they employ a variety of contradictory voices, assuming a tone of anonymous authority in order to express a wide spectrum of biases and beliefs in which truth is relative. *Blue Tilt* captures each of these signature moments in the medium most readily associated with Holzer—the LED.

The structure of *Blue Tilt*'s installation is architectural and dramatic, with imposing sixteen-foot, double-sided signs towering over viewers and bathing the entire space in the light of a relentless stream of words. "One reason I've stayed with LEDs so long," remarked Holzer, "is that part of the experience is that the light and words hit the body. This might give you vertigo; it might represent that there's always too much information and 'how do I process it?' It could make you unsure of the floor; I try to use reflections to that end."[2] Under her control, the gallery becomes a stage that at once creates and serves an audience that can no longer make itself comfortable.

L.D.

Steve McQueen

English, born 1969

Exodus

1992–97

Super 8 film, silent, transferred to digital video (monitor); 1:05 min. loop

Donna and Howard Stone New Media Fund, 2005.20

Girls, Tricky

2001

Digital color video, sound (projection); 14:47 min. loop

Wilson L. Mead Fund, through prior gift of Lucille L. and Joseph L. Block; Curator's Fund; and Cyrus Hall McCormick Fund, 2006.15

Caribs' Leap/Western Deep

2002

Caribs' Leap

8mm and 35mm color film, sound, transferred to two-channel digital video (projection); 28:53 min. loop, 12:06 min. loop

Western Deep

8mm color film, sound, transferred to digital video (projection); 24:12 min. loop

Marilynn Alsdorf Discretionary, Annabelle Decker, Wilson L. Mead, and Modern and Contemporary Discretionary funds; Robert and Marlene Baumgarten Endowment, 2003.86

Steve McQueen is an artist and filmmaker of Grenadian descent who was born and raised in London and lives in Amsterdam. In his reductive, often abstracted works, he pares down the projected image to its basic elements: light and dark, motion and stillness, silence and sound. The meanings in McQueen's intensely concentrated films and projected-image installations—some exquisitely choreographed, others improvised—are at once elusive, elliptical, and subtly transgressive. Avant-garde film traditions, including cinema verité and the revolutionary films of figures such as Buster Keaton, Jean Vigo, and Andy Warhol inform McQueen's improvisational approach, which is often defined by his preference for the handheld camera; distilled but coded actions, gestures, and performative expressions; and restrained post-production editing. Often, the bodies featured in the work include the artist's own; almost always, they are black. With little interest in excavating the repressed psychological history of the African diaspora or exploring identity politics per se, McQueen instead facilitates his subjects' creative empowerment through succinct works that leave ultimate interpretation to the viewer.

Exodus (see p. 1), McQueen's first mature effort, distinguishes itself from the balance of his oeuvre in that it captures an event that the artist happened to encounter while out with his handheld Super 8 camera. This short, silent film documents two smartly dressed men from the West Indies moving through the crowded streets of London. Each carries a potted coconut palm, a crude, if accidental, symbol of the tropics. Despite the burdens they carry and the challenges of navigating the city, they move efficiently through their environment, integrated with it even as the merrily waving palms above their heads distinguish them in the crowd. Their pace soon outstrips McQueen's, and they move away from the recording device that documents—even questions—their actions. They cross against oncoming traffic and deftly board a double-decker bus. The final scene shows one of the men waving from a rear window as the vehicle moves away. Like the 1977 song of the same name by renowned reggae singer Bob Marley, *Exodus* is a poetic, largely metaphoric consideration of experiences and migrations within the global black diaspora.[1]

Girls, Tricky (opposite) is a powerful, tough portrait of creativity in the extreme. Here, McQueen portrays the London-based experimental "trip-hop" musician and producer Tricky (born Adrian Thaws) as he rehearses a track in his dimly-lit recording studio. Four days spent together in this confined space resulted in an exquisitely intimate and sensitive representation of the singer. Of this experience, McQueen recalled:

> I wanted to get as close to the artist as possible. He has this certain je ne sais quoi, like Marlon Brando or James Dean. Tricky possesses a certain spontaneity, which also influenced the film. Tricky is someone who entrusts himself to his own voice and tries to find out where it may carry him. It's a rare moment that you see an artist close up gearing himself up for a vocal performance in such a visual way. In effect, a moment not for camera is caught.[2]

Gravesend

2007

35mm color film, sound, transferred to high-definition Quicktime movie file (projection); 18:04 min. loop

Through prior bequest of Mr. and Mrs. Joel Starrels; restricted gift of Donna and Howard Stone; through prior gifts of Fowler McCormick and Adeline Yates, 2008.479

Unexploded

2007

16mm color film, silent, transferred to digital video (projection or monitor); 54 sec. loop

Through prior bequest of Mr. and Mrs. Joel Starrels; restricted gift of Donna and Howard Stone; through prior gifts of Fowler McCormick and Adeline Yates, 2008.480

Indeed, Tricky erupts into an ecstatic near-frenzy with a performance that captures the camera's gaze for fifteen minutes straight, revealing only at the very end that he has maintained complete and utter command of the situation. As the critic Jerry Saltz noted, "*Girls, Tricky* lets you see how controlled this moment of losing control is and how ultra-conscious tapping into the subconscious is. At one point, just when you think Tricky is in another universe, he stops, opens his eyes, and calmly says, 'That was good; let's do it again.'"[3]

Most often shown in a single installation, *Caribs' Leap* and *Western Deep* are linked by images of falling and descent that are presented as allegories of oppression. McQueen filmed *Caribs' Leap* (p. 94) on Grenada, at the site of a historic mass suicide. In 1652, hundreds of Caribs threw themselves from the cliffs rather than surrender to the French army. The two looped channels are shown simultaneously, one depicting slow-motion dissolves of distant falling figures in gray-blue sky, the other showing scenes of the open ocean and the natural light of the beach. *Western Deep* (p. 95) takes the viewer, along with workers, more than three miles down into what is reputed to be the deepest South African goldmine. Like *Girls, Tricky*, in which the artist opted to preserve the dimness of the studio, *Western Deep* was shot in the mine's natural darkness, with portions of the film lit only when the miners turned on their headlamps. As in all of McQueen's work, the precisely controlled installation environment allows viewers to fully experience the artist's signature use of extreme dark and light, and phenomenological, sculptural sound.

Gravesend and *Unexploded*, when considered together, present a narrative of low-tech mining in the Congo, high-tech industrial production in England, and the complex traumas of the war in Iraq. Originally shot on 35mm film and transferred to high-definition digital format, *Gravesend* (opposite, at top and middle) enjoys significantly increased production values that allow each sequence to unfold in exquisite detail. The film alternates between images of a sterile British laboratory for the processing of columbite-tantalite, or coltan—a highly valuable metallic ore used in computer and communications technologies—and the dirty, arduous labor of extracting the mineral with rudimentary pickaxes, shovels, and the weathered hands of Congolese miners. The narrative is bisected by a silent series of still time-lapse shots that show the sun slowly setting over the silhouetted smokestacks of the factories in the industrial port town of Gravesend, to which the title refers.[4]

While they are two discrete works, *Gravesend* and *Unexploded* are meant to be seen in succession in one gallery space separated by a dividing wall. Only fifty-four seconds long and silent, *Unexploded* (at bottom) is encountered first, and is periodically affected by intense bursts of sound that spill over from the adjacent space. In *Gravesend*, the artist clearly departs from the rough, handheld aesthetic that defines earlier work such as *Exodus* and *Girls, Tricky*. He returns to it again in *Unexploded*, which has the timeless quality of found footage but was shot by McQueen in Basra, Iraq, and shows the damage to a building wrought by an unexploded bomb.

L.D./J.R.

Andrea Fraser

American, born 1955

Museum Highlights: A Gallery Talk

1989

Color video, sound; 29 min. loop

May I Help You?

1991

Color video, sound; 19 min. loop

Welcome to the Wadsworth: A Museum Tour

1991

Color video, sound; 25 min. loop

Inaugural Speech

1997

Color video, sound; 27 min. loop

Official Welcome

2001

Color video, sound; 29 min. loop

Contemporary Art Discretionary Fund; restricted gift of James Cahn and Jeremiah Collatz, 2008.82–86

Andrea Fraser is a performance and video artist who has been regarded primarily as a pioneer of "institutional critique," since she structures her work around existing museum practices and protocols such as gallery talks and welcome speeches. Although they often begin rationally, her performances progressively unravel, frequently devolving into discussions of eccentric topics or performances of taboo behaviors. Spanning more than a decade, the five works in the Art Institute's collection are among Fraser's earliest and most influential creations.

Museum Highlights: A Gallery Talk (above) documents Fraser's use of an invented persona—a formally attired, uptight docent named Jane Castleton—to present a social history of the art museum that focuses, as one scholar described it, on the "relationships between class and taste, private philanthropy and public policy."[1] The work was the first of its kind and remains a landmark in the recent history of performance art. *May I Help You?* (opposite, at top left), the only piece in this selection not performed by Fraser, features a monologue delivered by a commercial gallery director to visitors at an exhibition of the artist Allan McCollum's *Plaster Surrogates* (1982/90). In attempting to describe the display, the speaker projects a range of class fantasies and anxieties onto these essentially blank works, her speech eventually slipping into a self-revealing, contradictory monologue.

Welcome to the Wadsworth (at top right), which was commissioned by the Wadsworth Atheneum, documents a tour Fraser led there in April 1991. Rather than conducting visitors through the galleries, the artist takes them outside as she circles the perimeter of the museum campus, discussing the history of Hartford, Connecticut, as well as its fractured social and economic circumstances. Both *Inaugural Speech* and *Official Welcome* parody the rhetorical functions of institutional opening events. *Inaugural Speech* (at bottom left) deals with the politics of international group exhibitions of contemporary art in an era of increasing globalization. *Official Welcome* (at bottom right) questions the relationship between artists and patrons: at one point, Fraser completely disrobes to suggest the inherent exhibitionism involved in presenting art. The intelligence, clarity, and forcefulness of such performances have ensured that Fraser's oeuvre remains a touchstone for critically engaged art of the 1990s and beyond.

K.M.B.

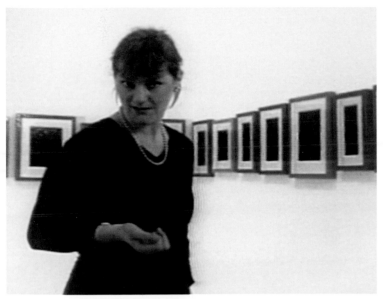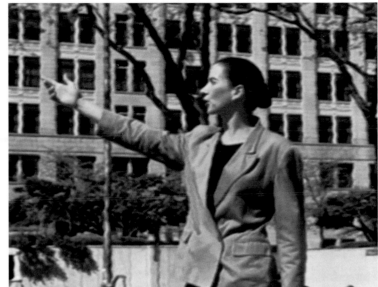
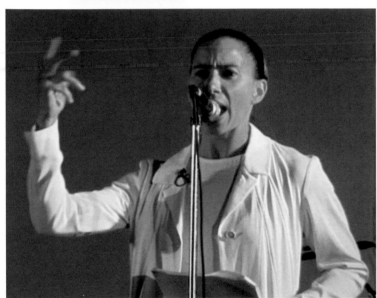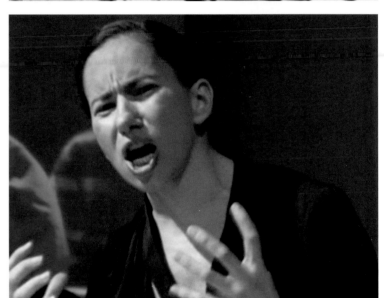

Fischli & Weiss

Peter Fischli
Swiss, born 1952

David Weiss
Swiss, born 1946

Questions
1981/2002–03

1215 slides, fifteen projectors, fifteen lenses, eight dissolve units; continuous loop

Jointly acquired by The Art Institute of Chicago through prior gift of Mr. and Mrs. Joel Starrels; Burt Kaplan Fund; through prior gift of Gould, Inc., and the Los Angeles Museum of Contemporary Art, purchased with funds provided by Acquisition and Collection Committee, 2008.208

Since 1979, the collaborative duo of Fischli & Weiss have imbued their art with a mix of absurdist humor, childlike wonder, existential inquiry, and an interest in the mundane. Their work—including books, films, mixed-media installations, photographs, sculptures, slide projections, and videos—incorporates aspects of Pop Art, Conceptual Art, and Dada yet defies association with any particular style. With a playful focus on the everyday, their art explores prosaic objects and experiences in a way that invests them with an unexpectedly sublime quality.

Questions, which combines profound metaphysical speculations and banal tribulations, exemplifies the willful ambiguity that pervades the artists' oeuvre. A large-scale, choreographed installation, the work utilizes fifteen slide projectors to cast hundreds of handwritten queries written in four different languages—English, German, Italian, and Japanese—in white on the walls of a dark room. The words, never ceasing to ask while proposing no answers, overlap each other, creating undulating patterns that slowly appear and quickly fade. The interrogations range from the empirical ("How long is the Nile?") to the absurd ("Is it true that traces of aliens have been found in yogurt?"), the personal ("Am I loved?"), and the metaphysical ("Do souls wander?"). "Our aim wasn't to think about the questions themselves too much," the artists explained, "but about someone coming up with all those questions. In very vague terms, we did imagine someone asking himself slightly paranoid questions that revolve very much around himself."[1] These, they think, are just the sort of questions that would run through his mind as he falls asleep, hence the dark room.

Questions have preoccupied Fischli & Weiss for over twenty-five years, first appearing in the photocopied publication *Order and Cleanliness* (1981), which accompanied the film *The Least Resistance* (1980–81). In that work, the artists, dressed in plush rat and bear costumes, ponder the limits of existence. They explored this terrain further in the book *Big Questions/Small Questions*, in which they juxtapose expansive questions such as "Where is the galaxy going?" with smaller ones like "Has the last bus gone?" The pair revisited these interrogations in 1984, when they lined the interior of *Question Pot*, a large polyurethane vessel, with one hundred questions in German. They first projected their queries in 2000 with three slide projectors, following this with a five-projector version and expanding it yet again with *Questions*, the large-scale work shown here. Along with a companion book, *Will Happiness Find Me?*, the piece debuted at the 2003 Venice Biennale, where it won the Golden Lion; soon thereafter, it entered the Art Institute's collection as a joint acquisition with the Los Angeles Museum of Contemporary Art.

Within its dreamlike atmosphere, *Questions* highlights the force of language, illuminating the concerns that haunt our psyches. Grand in scale and powerfully poignant, it evokes and transcends nearly every other work the artists have produced.

J.G.

PER ... NKEN?

AUSERWÄHL...?

KAN...RE MAN ALLES

ARA...?

KANTARE

NORMAL...

QUANTO FA... 42 × 87?

←3

WILL CHILDREN SING SONGS ABOUT

WARUM GEHT ES ...

...ING IN MY ...?

...EN NACH EINEM ARBEITSREICHEN TAG EIN SÜPPCHEN ZU ...

FÄHRT EIN BÄHNCHEN AUS DEM DRECK?

...ANGENS?

WHAT HAPPENED 4,56 BILLION YEARS AGO?

...REED ... LYING IN THE SUN ...

...MAI BEI DEN DUMM...?

TRASOGNATO E SENZA METÀ?

IS IT TRUE THAT TRACES OF ALIENS HAVE ... GHOST MARCHING NEXT TO ...

SOLL ICH MANDARINEN/PARFÜMIEREN UND EINE KERZE ANZÜNDEN?

...ETA VERSTAND ZWECKLOS?

WHAT'S A DOG ...

DEVO GIROVAGARE NEI BOA TUTTO UN SCHIFO SENZA SPERANZA?

...BEEN FOUND IN YOGURT?

DEVO LASCIARMICH/IST EIN UNSICHTBARER MENSCH BEI MIR?

...なんだろうか？

WHAT GOOD IS THE MOON?

WO SIND MEINE SCHLÜSSEL?

この犬、...。

SONO ... MAI STATO SVEGLIO DEL TUTTO?

...ICH EINE WAFFE KAUFEN?

IST ES HEUTE NOCH MÖGLICH, IN EINER HÖHLE ZU WOHNEN MIT EINER FRAU?

SOLL ICH MEINE BEZIEHUNG ZUR W...

A K Dolven

Norwegian, born 1953

Amazon

2005

16mm color film, silent; 1:34 min. loop

Claire and Gordon Prussian Fund for Contemporary Art, 2008.482

In her films, photographs, and videos, A K (Anne Katrine) Dolven explores notions of female beauty, the Romantic sublime, and temporal transformation. Rich in art-historical and conceptual references, her typically pared-down settings blend the surreal and uncanny with prosaic depictions of everyday rituals, subverting normal expectations—for example, a little girl's bedroom is inhabited by an elderly woman, Edvard Munch's 1902 woodcut *The Kiss* is restaged in a techno club, and a corporate office becomes the setting for a modern-day Madonna and Child.

Amazon—arguably the artist's most powerful film to date—depicts an androgynous archer repeatedly raising and drawing a bow, which casts sharp shadows across the figure's chest. Close-up views of neck, shoulder, and upper arm muscles snapping between tension and rest are visually dissected by short sequences and rapid changes in camera angle. As Andrea Schlieker observed, "Dolven has used the transformative power of the body fragment to great effect" in her films.[1] The choice of 16mm film and the small scale of the projected image add to the sense of intimacy conveyed by the close-up camera work. The artist has stated, "The way I use the frame in video is similar to the way I would use the four sides of a painting. I am interested in what we 'see' in the work, in how you touch the edge, but also how it touches upon an 'unseen' element, an element of the imagination, which exists outside the frame."[2] Vacillating between close-ups and mid-shots, the camera never reveals the identity of the protagonist, allowing the imagination to fill in the blanks.

Dolven deftly conveys a lifetime of experience in a fleeting one and a half minutes; the film is looped in such a way as to allow repeated viewings, each one divulging new information without ever telling the whole story. The piece ends with a quick mid-shot of the archer's bare torso, exposing a missing breast. Referring to the mythic race of female warriors who were said to cut off their right breasts to facilitate the drawing of the bow and increase the accuracy of their arrows, the title conveys the harnessed strength, courage, and physical determination required to overcome breast cancer and the other corporeal obstacles women may face.

L.D.

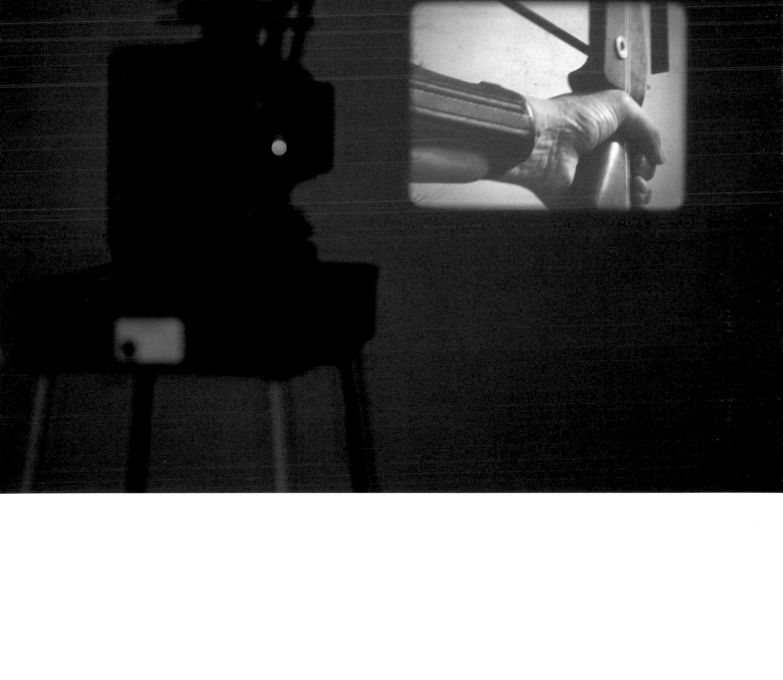

Elad Lassry

Israeli, born 1977

Zebra and Woman

2007

Super 16mm color film, silent; 5:21 min. loop

Wilson L. Mead Fund; Contemporary Art Discretionary and The Orbit funds, 2008.660

Untitled (Agon)

2007

Super 16mm color film, silent; 13:27 min. loop

Wilson L. Mead Fund; Contemporary Art Discretionary and The Orbit funds, 2008.659

Elad Lassry's films and photographs are distinguished by a rigorous formalism and a profound engagement with theories and histories of representation. Eschewing the labels of photographer and filmmaker, Lassry adopts the conceptual conceit of an artist using a camera; he is inspired by picture making in the tradition of practitioners such as Jack Goldstein, whose films, which resemble "moving photographs," reject narrative altogether.[1] Based in Los Angeles, Lassry creates elegant and economical compositions that take advantage of professional actors, animal trainers, and camera crews—works that at once draw upon and slyly critique the structures and institutions of Hollywood and the art world.

Zebra and Woman (at top) is a single-shot Super 16mm film that opens with an image of a wagging tail against a black background, suggesting the flickering of a motion picture.[2] As the camera pans over a zebra's hide, the animal's breath causes a visual vibration. The black-and-white pattern, which eventually fills the entire screen, evokes the Op Art paintings of Bridget Riley as well as the compositional experiments of Morris Louis, referencing in particular *Alpha-Pi* (1960), a work from his *Unfurled* series in which multicolored paint rivulets seemingly enter from outside the picture and flow diagonally toward the empty white center of an unprimed canvas. In a similar treatment, Lassry's camera passes over the zebra's body and head, moving through an empty blackness to reveal a close-up of a beautiful blonde woman portrayed by actress Radha Mitchell.[3] In this way, the artist transforms his literal subjects—the zebra and the woman—into a means of presenting a space that is both cinematic and painterly. As in the work of William Wegman (see p. 22) and Diana Thater (see pp. 56–57), human and animal relationships figure prominently in Lassry's oeuvre. Here, he addresses the psychological void between his subjects, which he represents by the pan through darkness, and also explores their respective experiences of portraiture.

Untitled (Agon) (at bottom) features dancers Megan LeCrone and Ask La Cour of the New York City Ballet performing the last sequence of George Balanchine's *Agon* (1957). Lassry's silent film further abstracts Balanchine's decidedly modernist choreography by removing Igor Stravinsky's accompanying musical score. The film begins with a close-up of LeCrone's face as she internally rehearses the steps she is about to perform on the floor; her subtly shifting eyes and head allude to the body movements to come. Once the couple has completed the pas de deux, the camera hones in on La Cour's face, and the film comes full circle as he mentally reviews his routine. Using a predetermined visual approach that nods to the work of structural filmmakers such as Michael Snow (see pp. 14–15), Lassry positions his camera according to an instructional diagram from dancer and choreographer Doris Humphrey's groundbreaking book *The Art of Making Dances* (1959). As in *Zebra and Woman*, and many of his other works, the artist explores the function and parameters of portraiture—in this instance, not only of the dancers, but of the dance itself.

L.D.

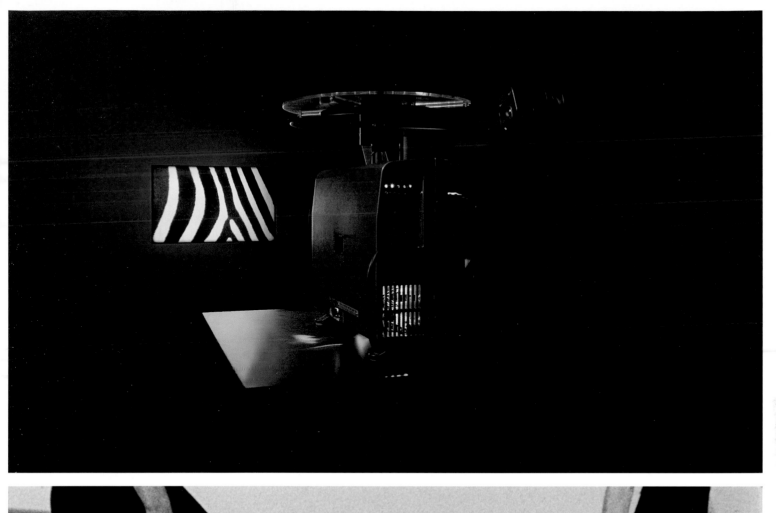

CHECKLIST

Vito Acconci, pp. 66–67
American, born 1940
Centers, 1971
Black-and-white video, sound; 22.43 min.
New Media Art Study Collection, Obj. 189060

Eija-Liisa Ahtila, pp. 52–53
Finnish, born 1959
Talo/The House, 2002
Super 16mm color film transferred to three-channel
video (projection, 5:1 surround sound); 14 min. loop
Edition number five of five
Jointly acquired by The Art Institute of Chicago,
Contemporary Art Discretionary Fund and W. L.
Mead Endowment; and the Los Angeles Museum of
Contemporary Art, purchased with funds provided by
the Acquisition and Collection Committee and Bob
Tuttle, 2004.483

Doug Aitken, pp. 72–75
American, born 1968
monsoon, 1995
Color film, sound, transferred to digital video (monitor
or projection); 6:43 min. loop
Edition number one of five
Gift of Donna and Howard Stone, 2007.33

thaw, 2001
Color film, sound, transferred to three-channel digital
video (projection on three attached screens);
4:10 min. loop
Edition number four of four
Gift of Society for Contemporary Art, 2002.79

the moment, 2005
Eleven-channel digital video, sound (projected on
plasma screens with mirrors); 6:30 min.
Edition number one of four
Gift of Donna and Howard Stone, 2007.34

Darren Almond, pp. 70–71
English, born 1971
Schwebebahn, 1995
8mm black-and-white and color film, sound,
transferred to digital video (projection); 12 min. loop
Edition number one of five
Gift of Donna and Howard Stone, 2007.32

Kenneth Anger, p. 13
American, born 1927
Kustom Kar Kommandos, 1965
16mm color film, sound; 3:30 min.
Gift of Society for Contemporary Art, Obj. 184148

Janine Antoni, pp. 86–87
Bahamian, born 1964
Touch, 2002
Color video, sound (projection); 9:36 min. loop
Edition number three of five
Gift of Donna and Howard Stone, 2007.43

John Baldessari, pp. 66–67
American, born 1931
Baldessari Sings LeWitt, 1972
Black-and-white video, sound; 12:50 min. loop
New Media Art Study Collection, Obj. 189072

Vanessa Beecroft, p. 76
Italian, born 1969
Piano Americano, 1996
Color video, sound (projection); 30 min. loop
Edition number six of eight
Gift of Donna and Howard Stone, 2007.35

Jordan Belson, p. 15
American, born 1926
World, 1970
16mm color film, sound; 6 min.
Gift of Society for Contemporary Art, Obj. 184156

Zarina Bhimji, pp. 44–45
Ugandan, born 1964
Out of Blue, 2002
16mm color film, sound, transferred to digital video
(projection); 24:25 min. loop
Edition number one of four
Restricted gift of Barbara Ruben in memory of Thomas
H. Ruben, 2004.147

Dara Birnbaum, pp. 66–67
American, born 1946
*Technology/Transformation: Wonder
Woman,* 1978–79
Color video, sound; 7 min. loop
New Media Art Study Collection, Obj. 189065

Stan Brakhage, pp. 12–13
American, 1933–2003
Wonder Ring, 1955
16mm color film, silent; 4 min.
Gift of Society for Contemporary Art, Obj. 184158

Prelude to Dog Star Man, 1961
16mm color film, silent; 25 min.
Gift of Society for Contemporary Art, Obj. 184157

Robert Breer, p. 12
American, born 1926
Man and His Dog Out for Air, 1957
16mm black-and-white film, sound; 3 min.
Gift of Society for Contemporary Art, Obj. 184159

Bruce Conner, pp. 12–13
American, 1933–2008
A Movie, 1958
16mm black-and-white film, sound; 12 min.
Gift of Society for Contemporary Art,
Obj. 184164

Cosmic Ray, 1961
16mm black-and-white film, sound; 4:30 min.
Gift of Society for Contemporary Art, Obj. 184163

Joseph Cornell, p. 12
American, 1903–1972
The End is the Beginning, 1955
Super 8 color film, sound, transferred to 16mm film;
5 min.
Gift of Society for Contemporary Art, Obj. 184165

Tacita Dean, pp. 36–37
English, born 1965
*Disappearance at Sea II (Voyage de
Guérison),* 1997
16mm anamorphic color film, optical sound;
4 min. loop
Gift of Society for Contemporary Art, 2000.97

Rineke Dijkstra, pp. 38–39
Dutch, born 1959
Annemiek, February 11, 1997, 1997
Color video, sound (projection); 4 min. loop
Edition number two of eight
Modern and Contemporary Discretionary Fund,
2000.312

A K Dolven, pp. 102–103
Norwegian, born 1953
Amazon, 2005
16mm color film, silent;
1:34 min. loop
Edition number five of five
Claire and Gordon Prussian Fund for Contemporary
Art, 2008. 482

Jeanne Dunning, p. 77
American, born 1960
Icing, 1996
Color video, sound (projection); 30 min. loop
Edition number one of six
Gift of Donna and Howard Stone, 2007.36

Fischli & Weiss, pp. 100–01

Peter Fischli
Swiss, born 1952

David Weiss
Swiss, born 1946

Questions, 1981/2002–03
1215 slides, fifteen projectors, fifteen lenses, eight dissolve units; continuous loop
Edition number two of three
Jointly acquired by The Art Institute of Chicago through prior gift of Mr. and Mrs. Joel Starrels; Burt Kaplan Fund; through prior gift of Gould, Inc., and the Los Angeles Museum of Contemporary Art, purchased with funds provided by Acquisition and Collection Committee, 2008.208

Andrea Fraser, pp. 98–99
American, born 1955

Museum Highlights: A Gallery Talk, 1989
Color video, sound; 29 min. loop

May I Help You?, 1991
Color video, sound; 19 min. loop

Welcome to the Wadsworth: A Museum Tour, 1991
Color video, sound; 25 min. loop

Inaugural Speech, 1997
Color video, sound; 27 min. loop

Official Welcome, 2001
Color video, sound; 29 min. loop
Contemporary Art Discretionary Fund; restricted gift of James Cahn and Jeremiah Collatz, 2008.82–86

Kendell Geers, p. 40
South African, born May 1968

Tears for Eros, 1999
Color video, sound (five monitors), metal scaffolding; dimensions vary with installation
Edition number one of three
Donna and Howard Stone New Media Fund, 2000.48

Nan Goldin, pp. 62–63
American, born 1953

The Ballad of Sexual Dependency, 1979–2001
35mm color slide installation (720 slides with programmed soundtrack); 43 min. loop
Edition number seven of ten
Through prior bequest of Marguerita S. Ritman; restricted gift of Dorie Sternberg, the Photography Associates, Mary L. and Leigh B. Block Endowment, Robert and Joan Feitler, Anstiss and Ronald Krueck, Karen and Jim Frank, Martin and Danielle Zimmerman, 2006.158

Rodney Graham, pp. 58–59
Canadian, born 1949

Torqued Chandelier Release, 2005
35mm color film, silent (custom film projector at 48 fps); 5 min. loop
Edition number one of three
Major Acquisitions Fund, 2005.292

David Hammons, pp. 60–61
American, born 1943

Phat Free, 1995/99
Color video, sound, transferred to digital video (projection, surround sound); 5:20 min. loop
Unnumbered from an edition of twenty-five
Through prior gifts of Mary and Leigh Block and Florence S. McCormick; Robert and Marlene Baumgarten Endowment; and anonymous gift, 2005.294

Gary Hill, pp. 28–29
American, born 1951

Inasmuch As It Is Always Already Taking Place, 1990
Sixteen-channel black-and-white video, sound (sixteen cathode ray tubes); 5- to 30-second loops, 16 x 54 x 66 in. (40.6 x 137.2 x 167.6 cm), niche recessed into wall
Edition number one of two
Gift of Lannan Foundation, 1997.144

Will Hindle, p. 15
American, 1929–1987

Billabong, 1968
16mm color film, sound; 9 min.
Gift of Society for Contemporary Art, Obj. 184166

Jenny Holzer, pp. 90–91
American, born 1950

Blue Tilt, 2004
Six double-sided vertical LED signs with Triton blue diodes, stainless steel housings, and bezels; each 381 x 13.7 x 13.7 cm (150 x 5 3/8 x 5 3/8 in.)
Restricted anonymous gift; through prior bequest of Marguerita S. Ritman; through prior gift of Leo S. Guthman; Watson F. Blair Prize Fund, 2007.357

Pierre Huyghe, pp. 68–69
French, born 1962

Les Grands Ensembles (The Housing Projects), 1994/2001
VistaVision film, sound, transferred to digital video (projection on screen); 7:51 min. loop
Artist proof one of two, from an edition of five
Gift of Donna and Howard Stone, 2007.31

Directed by
Isaac Julien, pp. 82–83
English, born 1960

Choreography and movement material by
Javier De Frutos
Venezuelan, born 1963

The Long Road to Mazatlán, 2000
16mm black-and-white and color film, sound, transferred to three-channel digital video (rear projection on screen); 18 min. loop
Gift of Donna and Howard Stone, 2007.41

Amar Kanwar, pp. 48–49
Indian, born 1964

A Season Outside, 1997
16mm color film, sound, transferred to digital video (projection); 30 min. loop
Edition number two of six
Restricted gift of Martin Friedman and Peggy Casey-Friedman; Contemporary Art Discretionary Fund, 2004.481

William Kentridge, pp. 30–33
South African, born 1955

Johannesburg—2nd Greatest City after Paris, 1989
16mm color film, sound, transferred to digital video (projection); 8:02 min.

Monument, 1990
16mm color film, sound, transferred to digital video (projection); 3:11 min.
Edition number five of ten

Mine, 1991
16mm color film, sound, transferred to digital video (projection); 5:49 min.
Edition number five of ten

Sobriety, Obesity & Growing Old, 1991
16mm color film, sound, transferred to digital video (projection); 8:15 min.
Edition number five of ten
Gift of The Peter Norton Family Foundation, 1998.353–56

Ubu Tells the Truth, 1997
35mm color film, sound, transferred to digital video (projection); 8 min.
Edition three of four
Gift of Donna and Howard Stone, 2007.38

Elad Lassry, pp. 104–05
Israeli, born 1977

Zebra and Woman, 2007
Super 16mm color film, silent; 5:21 min. loop
Edition number one of three
Wilson L. Mead Fund; Contemporary Art Discretionary and The Orbit funds, 2008.660

Untitled (Agon), 2007
Super 16mm color film, silent; 13:27 min. loop
Wilson L. Mead Fund; Contemporary Art Discretionary
and The Orbit funds, 2008.659

Sharon Lockhart, pp. 50–51
American, born 1964

NO, 2003
16mm color film, optical sound; 32:30 min. loop
Edition number three of six
Restricted gift of C. Bradford Smith and Donald L.
Davis; Contemporary Art Discretionary and The Orbit
funds, 2004.482

Iñigo Manglano-Ovalle, pp. 34–35
American, born Spain, 1961

Sonambulo II (Blue), 1999
Compact disc, blue-tinted polyester window film,
existing architectural space; 13 min. loop
Jacob and Bessie Levy Art Encouragement Fund,
1999.299

Gordon Matta-Clark, pp. 64–65
American, 1943–1978

Splitting, 1974
Super 8 black-and-white and color film, silent,
transferred to 16mm film; 10:50 min.
Edition number seven of ten
Restricted gift of Dirk S. Denison, 2006.747

Albert Maysles, p. 16
American, born 1926
David Maysles
American, 1931–1987
Ellen Hovde
American, born 1925

Christo's Valley Curtain, 1973
16mm color film, sound; 28 min.
Gift of Society for Contemporary Art, Obj. 184162

Steve McQueen, pp. 92–97
English, born 1969

Exodus, 1992–97
Super 8 film, silent, transferred to digital video
(monitor); 1:05 min. loop
Edition number two of four
Donna and Howard Stone New Media Fund, 2005.20

Girls, Tricky, 2001
Digital color video, sound (projection);
14:47 min. loop
Edition number three of four
Wilson L. Mead Fund, through prior gift of Lucille L.
and Joseph L. Block; Curator's Fund; and Cyrus Hall
McCormick Fund, 2006.15

Caribs' Leap/Western Deep, 2002
Caribs' Leap
8mm and 35mm color film, sound, transferred to two-
channel digital video (projection); 28:53 min. loop,
12:06 min. loop

Western Deep
8mm color film, sound, transferred to digital video
(projection); 24:12 min. loop
Edition number two of four

Marilynn Alsdorf Discretionary, Annabelle Decker,
Wilson L. Mead, and Modern and Contemporary
Discretionary funds; Robert and Marlene Baumgarten
Endowment, 2003.86

Gravesend, 2007
35mm color film, sound, transferred to high-definition
Quicktime movie file (projection); 18:04 min. loop
Edition number five of six
Through prior bequest of Mr. and Mrs. Joel Starrels;
restricted gift of Donna and Howard Stone; through
prior gifts of Fowler McCormick and Adeline Yates,
2008.479

Unexploded, 2007
16mm color film, silent, transferred to digital video
(projection or monitor); 54 sec. loop
Edition number five of six
Through prior bequest of Mr. and Mrs. Joel Starrels;
restricted gift of Donna and Howard Stone; through
prior gifts of Fowler McCormick and Adeline Yates,
2008.480

Helen Mirra, p. 41
American, born 1970

*Map of Parallel 52 North at a Scale of One
Foot to One Degree*, 1999
Hand-painted 16mm color film, silent, with film reel,
can, and lid in vitrine; 11 min loop
Edition number one of four
Ann M. Vielehr Prize Fund, 2001.485

Mariko Mori, p. 78
Japanese, born 1967

Miko No Inori, 1996
Color video with capsule and crystal; 29:23 min.
Edition number forty-one of one hundred
Gift of Donna and Howard Stone, 2007.37

Robert Morris, p. 16
American, born 1931

Neo Classic, 1971
16mm black-and-white film, silent; 15:30 min.
Gift of Society for Contemporary Art, Obj. 184167

Joshua Mosley, pp. 42–43
American, born 1974

Beyrouth, 2001
Digital color video, sound (projection);
9 min. loop
Edition number three of five
Pauline Palmer Prize Fund, 2003.87

A Vue, 2004
High-definition color video, sound (projection);
7:30 min. loop
Edition number four of five
Gift of Donna and Howard Stone, 2007.45

dread, 2007
High-definition color video, sound (projection);
6 min. loop
Edition number four of five
Wilson L. Mead Fund, 2008.80

Bruce Nauman, pp. 15–16, 18–21
American, born 1941

Art Make-Up, Nos. 1–4, 1967–68
Four 16 mm color films, silent, shown simultaneously:
Art Make-Up, No. 1: White, 1967; *Art Make-Up, No. 2:
Pink*, 1967–68; *Art Make-Up, No. 3: Green*, 1967–68; *Art
Make-Up, No. 4: Black*, 1967–68; 10 min. loop
Twentieth-Century Purchase Fund, 1974.229a–d

*Dance or Exercise on the Perimeter of a
Square (Square Dance)*, 1968
16mm black-and-white film, sound; 11 min.
Gift of Society for Contemporary Art, Obj. 184168

Good Boy Bad Boy, 1985
Two color videos, sound, two monitors on two
pedestals; Tape I (male): 60 min. loop; Tape II
(female): 52 min. loop
Edition number twenty-nine of forty
Gift of Lannan Foundation, 1997.150

Clown Torture, 1987
Four-channel digital video, sound (two projections,
four monitors); 60 min. loop
Tape I/Reel A: "Clown Taking a Shit"
Tape II/Reel B: "Clown With a Goldfish," "Clown With
Water Bucket," Reel C: "Pete and Repeat," Reel D: "No,
No, No, No (Walter),"
Tape III/ Reel C: "Pete and Repeat," Reel D: "No, No,
No, No (Walter),"
Reel B: "Clown With Goldfish," "Clown With Water
Bucket"
Tape IV/ Reel D: "No, No, No, No (Walter),"
Reel B: "Clown With a Goldfish," "Clown With Water
Bucket," Reel C: "Pete and Repeat"
Watson F. Blair Prize, Wilson L. Mead and Twentieth-
Century Purchase funds; through prior gift of Joseph
Winterbotham; gift of Lannan Foundation, 1997.162

Robert Nelson, p. 14
American, born 1930

Oh Dem Watermelons, 1965
16mm color film, sound; 12 min.
Gift of Society for Contemporary Art, Obj. 184170

Shirin Neshat, pp. 80–81
Iranian, born 1957

Rapture, 1999
Two-channel black-and-white video, sound
(projection); 13 min. loop
Edition number one of five
Gift of Donna and Howard Stone, 2007.40

Nam June Paik, pp. 26–27
American, born Korea, 1932–2006

Family of Robot: Baby, 1986
Color video, silent, thirteen monitors and aluminum
armature; 133.3 x 96.2 x 20.3 cm (52 1/2 x 37 7/8 x 8 in.)
Gift of Society for Contemporary Art, 1992.283

Hirsch Perlman, pp. 84–85
American, born 1960

Two Affect Studies, 2001
Two color videos, sound (projection); 15 min. loop
Artist's proof number two of two, from an edition
of three
Gift of Donna and Howard Stone, 2007.42

Charles Ray, pp. 46–47
American, born 1953

Fashions, 1996
16mm color film, silent, projector, pedestal, and seating;
12:30 min.
From an unnumbered edition of four
Pauline Palmer Prize Fund, 2004.150

Ed Ruscha, pp. 16–17
American, born 1937

Premium, 1971
16mm color film, sound; 30 min.
Gift of Society for Contemporary Art, Obj. 184171

Anri Sala, pp. 88–89
Albanian, born 1974

Blindfold, 2002
Two-channel digital color video, six-channel digital
sound (rear projection on two Plexiglas screens); 15
min. loop
Gift of Donna and Howard Stone, 2007.44

Mixed Behaviour, 2003
Digital color video, sound (projection); 8:17 min. loop
Artist's proof number one of three, from an edition
of six
Donna and Howard Stone New Media Fund, 2005.21

George Segal, pp. 10–11
American, 1924–2000

The Truck, 1966
Metal, plaster, glass, wood, plastic, 16mm color film,
silent, transferred to digital video (projection); 167.6 x
558.8 x 152.4 cm (66 x 220 x 60 in.)
Mr. and Mrs. Frank G. Logan Purchase Prize Fund,
1966.336

Richard Serra, pp. 14–15
American, born 1939

Hand Catching Lead, 1968
16mm black-and-white film, silent; 3:30 min.
Gift of Society for Contemporary Art, Obj. 184173

Hands Scraping, 1968
16mm black-and-white film, silent; 3:30 min.
Gift of Society for Contemporary Art, Obj. 184174

Michael Snow, pp. 14–15
Canadian, born 1929

Wavelength, 1966–67
16mm color film, sound; 45 min.
Gift of Society for Contemporary Art, Obj. 184176

Bob Snyder, p. 23
American, born 1946

Lines of Force, 1979
Color video, sound; 10 min.

Trim Subdivisions, 1981
Color video, sound; 6 min.
Gifts of Society for Contemporary Art, 1983.265–66

Sam Taylor-Wood, p. 79
English, born 1967

Hysteria, 1997
16mm color film, silent, transferred to digital video
(projection); 8 min. loop
Edition number two of three
Gift of Donna and Howard Stone, 2007.39

Diana Thater, pp. 56–57
American, born 1962

Delphine, 1999
Five-channel digital color video, sound (projection),
with nine-monitor video cube, light filters, and existing
architecture; continuous loop
Artist's proof from an edition of three
Donna and Howard Stone New Media Fund, 2005.93

Salla Tykkä, pp. 54–55
Finnish, born 1973

Lasso, 2000
35mm color film, stereo sound, transferred to digital
video (projection); 3:48 min. loop
Artist's proof from an edition of seven
Restricted gift of Stephanie Skestos Gabriele and Dirk
Denison, 2005.21

Stan VanDerBeek, p. 13
American, 1927–1984

Science Friction, 1959
16mm color film, sound; 9 min.
Gift of Society for Contemporary Art, Obj. 184177

Bill Viola, pp. 24–25
American, born 1951

*The Reflecting Pool: Collected Works,
1977–80*

The Reflecting Pool, 1977–79, 6:58 min.
Moonblood, 1977–79, 12:40 min.
Silent Life, 1979, 13:14 min.
Ancient of Days, 1979–81, 12:21 min.
Vegetable Memory, 1978–80, 15:13 min.
Color video, sound (projection); 62 min. loop
Gift of Society for Contemporary Art, 1983.277

Reasons for Knocking at an Empty House,
1982
Color video, sound (monitor), wood chair,
headphones, spotlight, and pedestal; dimensions
vary with installation
Restricted gifts of Barbara Bluhm, Frances Dittmer,
Ruth Horwich, Susan and Lewis Manilow, Marcia and
Irving Stenn, Jr., Dr. and Mrs. Paul Sternberg, and Lynn
and Allen Turner; through prior acquisitions of Leigh
and Mary Block, 1993.246

William Wegman, p. 22
American, born 1943

Selected Works, 1972–73
Black-and-white videos, sound;
Reel Two: 10 min; Reel Three: 16 min.
Twentieth-Century Purchase Fund, 1974.224a–b

NOTES

Lisa Dorin, "'Here to Stay': Collecting Film, Video, and New Media at the Art Institute of Chicago," pp. 6–9.

1. Two of the earliest such works to enter major museums were Les Levine's multimedia video installation *Iris* (1968), which was purchased for the Philadelphia Museum of Art in 1968, and Dan Graham's film loop *Two Correlated Rotations* (1970–72), acquired by the Tate Gallery, London, in 1973. For more on this history, see Chrissie Iles and Henriette Huldisch: "Keeping Time: On Collecting Film and Video Art in the Museum," in *Collecting the New: Museums and Contemporary Art*, ed. Bruce Altshuler (Princeton University Press, 2005).
2. Together, Tom DeFanti and Dan Sandin created the Circle Graphics Habitat, now known as the Electronic Visualization Laboratory, at the University of Illinois-Chicago. Bob Snyder, who began and chaired the Sound Department at the School of the Art Institute, is represented in the Art Institute's collection with two video works (see p. 23 in this publication). In 1980, the Museum of Contemporary Art, Chicago, hosted *Video Art: The Electronic Medium*, an exhibition that featured these and other Chicago-based electronic media pioneers.
3. The Art and Technology Department was originally known as Generative Systems. Video Data Bank, which started as an internal resource for students in 1972, was formally incorporated and given a dedicated space in 1976. Joyce Bolinger, "Profile: Video Data Bank," *SCAN: The Center for New Television* 7, 1 (Winter 1984), p. 4.
4. The Society for Contemporary Art also fulfills an educational mission, hosting a number of lectures and programs each year; its acquisition schedule has at times been biannual.
5. Maya Deren's *Meshes of the Afternoon* (1943) and a film documenting Robert Smithson's *Spiral Jetty* (1970) were not purchased.
6. "Contemporary Film Art," exh. list, 1973. Curatorial files, Department of Contemporary Art.
7. In the video art of the 1980s, formal and technical innovation gave way to appropriation, media critique, and activist practices focusing particularly on the AIDS crisis. Much of this work had a decidedly anti-art perspective that many museums may have found challenging to reconcile with their larger collections.
8. For more information on the Lannan gift, see *Art Institute of Chicago Museum Studies* 25, 1 (1999).
9. Steve McQueen was a Turner Prize recipient in 1999. His recent feature film *Hunger* premiered at the 2008 Cannes Film Festival, where it received a Camera d'Or for a first-time director. The artist was also selected as the British representative to the 2009 Venice Biennale. *Gravesend* and its companion piece *Unexploded* were commissioned by the Renaissance Society at the University of Chicago and debuted at the 52nd Venice Biennale before the Art Institute acquired them in 2008.

10. Iles and Huldisch (note 1) discuss in detail the specific challenges facing museums with regard to the collection of electronic media; see pp. 65–83.
11. In 2003, the Art Institute's Auxiliary Board funded a conservation effort that produced a new internegative, or master film reel, for *Art Make-Up*. For more on this project, see Suzanne R. Schnepp. "On Time: Approaches to the Conservation of Film, Videotape, and Digital Media," *Art Institute of Chicago Museum Studies* 31, 2 (2005), pp. 96–102.
12. While most film archivists agree that 16mm is in sharp decline, some contend that it may disappear completely in the span of fifty years or less, and there is debate as to what will replace it once it is gone. It is generally agreed that 16mm might be converted to 35mm for archiving in certain cases, but that digital processes are more likely to eventually replace all celluloid formats.

George Segal, pp. 10–11.

1. A. James Speyer, "Introduction," *Sixty-Eighth American Exhibition*, exh. cat. (Art Institute of Chicago, 1966).
2. "One for the Road," *Time*, Aug. 26, 1966, www.time.com/time/magazine/article/0,9171,842698,00.html.

Gifts of Society for Contemporary Art, 1973, pp. 12–17.

1. "Contemporary Film Art," exh. list, 1973. Curatorial files, Department of Contemporary Art.
2. Jane Allen and Derek Guthrie, "Fourteen Portraits of the Artists as Filmmakers," *Chicago Tribune*, May 20, 1973, p. E21.
3. Due to the unusual nature of the collaboration among the Society for Contemporary Art, the Film Center, and the Art Institute, the films were not accessioned into the museum's permanent collection at the time, but rather resided at the Film Center, where they were made available to curators for exhibition and study and served as a valuable resource for faculty and students at the School.
4. Most of these were purchased in 1973 from Castelli-Sonnabend Films and Tapes, a joint venture between the famed dealers Leo Castelli and Ileana Sonnabend.
5. Brian Frye, "Stan Brakhage," http://archive.sensesofcinema.com/contents/directors/02/brakhage.html.
6. Cornell's *The End is the Beginning* (1955), also titled *Gnir Rednow* (*Wonder Ring* spelled backward), is his own version of Brakhage's film, consisting of edited outtakes from *Wonder Ring*.
7. Quoted in Peter Boswell, *2000 B.C.: The Bruce Conner Story Part II*, exh. cat. (Walker Art Center, 2000), p. 32.
8. In fact, Serra recalled that it was Rainer's *Hand Movie* (1966) that suggested the idea of making film. See Annette Michelson, Richard Serra, and Clara Weyergraf, "The Films of Richard Serra: An Interview," *October* 10 (Fall 1979), p. 68.
9. Mark Pascale, "Bruce Nauman," *Art Institute of Chicago Museum Studies* 25, 1 (1999), p. 40.
10. "Neo Classic, 1971," www.tate.org.uk/servlet/ViewWork?cgroupid=999999961&workid=71553&searchid=11786.

11. Mason Williams, "How to Derive the Maximum Pleasure from Crackers," in *The Mason Williams Reading Matter* (Doubleday, 1969).

Bruce Nauman, pp. 18–21.

1. Quoted in Coosje van Bruggen, *Bruce Nauman* (Rizzoli, 1988), p. 239.
2. *Clown Torture* is included—along with photographs and works in bronze and neon—in a gallery dedicated to Nauman in the inaugural installation of the Art Institute's Modern Wing.
3. Joan Simon, "Breaking the Silence: An Interview with Bruce Nauman," *Art in America* 76 (Sept. 1988), p. 203.
4. Quoted in Joan Simon, "Breaking the Silence," in *Bruce Nauman*, ed. Robert C. Morgan (Johns Hopkins University Press, 2002), p. 271.

William Wegman, p. 22.

1. For more on the exhibition, see Anne Rorimer, *Idea and Image in Recent Art* (Art Institute of Chicago, 1974).
2. In the exhibition *Idea and Image in Recent Art*, Wegman's work was presented alongside Baldessari's *The Pencil Story* (1973).
3. Wegman remastered the entire series of *Selected Works* in 2005, transferring the videos to DigiBeta and adding previously unreleased titles to each reel. This discussion addresses those works that are included within the original tapes, Reel Two (1972) and Reel Three (1973). The contents of Reel Two (trt 10 min.) are *Coin Toss* (2:11); *Diving Board* (0:47); *In the Cup* (0:16); *The Kiss* (1:27); *Monkey Business* (1:06); *Product* (1:31); *Same Shirt* (0:32); *Sanforized* (0:47); *Straw and String* (0:51); and *Treat Bottle* (4:18). Reel Three (trt 16 min.) comprises *Born with No Mouth* (1:00); *Bubble Up* (0:59); *Crooked Finger, Crooked Stick* (0:39); *Deodorant* (0:49); *Dual Function* (1:33); *Emperor and Dish* (1:09); *47 Seconds* (1:00); *Lucky T-Shirt* (1:04); *Man Ray, Do You Want To?* (2:03); *Massage Chair* (1:35); *Rage and Depression* (1:03); *Raise Treat* (0:25); and *Stick and Tooth* (1:00).

Bob Snyder, p. 23.

1. For more on Snyder and Sandin's collaboration, see note 2 of my introductory essay, above.
2. In 1983—the year *Trim Subdivisions* entered the Art Institute's collection— it had also recently been acquired by the Museum of Modern Art, New York, and was included in a special video program curated by John Hanhardt as part of that year's Whitney Biennial.

Bill Viola, pp. 24–25.

1. Commenting on his decision to begin working in video, Viola stated: "Video was ideal because it was a radical new tool, the newest of the new, without any tradition—against television, independent of sculpture, painting, photography and even cinema, or so I thought." *Bill Viola*, exh. cat. (Whitney Museum of American Art/Flammarion, 1997), p. 156.
2. Ibid., p. 143.
3. Ibid.

Nam June Paik, pp. 26–27.

1. Edith Decker-Phillips, *Paik Video* (Barrytown, N.Y.: Station Hill Arts/Barrytown, Ltd., 1998), p. 31.
2. Paik contemplated using televisions and created illustrations of his ideas in the late 1950s; he was secretly experimenting with the medium and did not reveal his projects until 1963; see ibid. pp. 32–33, 50. The date that the first battery-operated Sony Portapak became available in the United States has been recently debated; see Tom Sherman, "The Premature Birth of Video Art," *Video History Project*, www.experimentaltvcenter.org/history/people/ptext.php3?id=200&page=1.
3. Jacquelyn D. Serwer, "Nam June Paik: 'Technology,'" *American Art* 8, 2 (Spring 1994), p. 91; and Walter Robinson, "Nam June Paik at Holly Solomon," *Art in America* 75, 6 (June 1987), p. 157.
4. Quoted in Wulf Herzogenrath, *Nam June Paik: Fluxus, Video* (Kunsthalle Bremen, 1999), p. 30.
5. Roberta Smith, "Out of the Wasteland: An Avant-gardist's Obsession with Television," *Newsweek*, Oct. 13, 1986, p. 67.

Gary Hill, pp. 28–29.

1. Gary Hill, "Interviewed Interview," in *Gary Hill*, ed. Gary Hill and Christine van Assche, exh. cat. (IVAM Centre Del Carme, 1993), p. 151.
2. Quoted in Corinne Diserens, "Time in the Body," in *Gary Hill*, ed. Robert C. Morgan (Johns Hopkins University Press, 2000), p. 60.
3. Barbara London, "Gary Hill," in *Video Spaces: Eight Installations*, exh. cat. (Museum of Modern Art/Harry N. Abrams, 1995), pp. 22–23.
4. Daniel Schulman, "Gary Hill," *Art Institute of Chicago Museum Studies* 25, 1 (1999), p. 72.

William Kentridge, pp. 30–33.

1. William Kentridge, "Felix in Exile: Geography of Memory," excerpted in Carolyn Christov-Bakargiev, *William Kentridge*, exh. cat. (Brussels: Société des expositions du Palais des beaux-arts, 1998), p. 14.
2. Ibid., p. 97.
3. These are the first four films in the series.
4. The Art Institute's Department of Prints and Drawings acquired these etchings in 1998.
5. For a discussion of music in Kentridge's films, see Michael Godby, "William Kentridge: Retrospective," *Arts Journal* 58, 3 (1999), pp. 84–85.

Iñigo Manglano-Ovalle, pp. 34–35.

1. The gunshot was recorded in 1995; the mix and resulting installation were made in 1999.
2. "Interview with Iñigo Manglano-Ovalle by Michael Rush," in Irene Hofmann, *Iñigo Manglano-Ovalle*, exh. cat. (Cranbrook Art Museum, 2001), p. 60.

Tacita Dean, pp. 36–37.

1. In her film *Teignmouth Electron* (1999), Dean filmed the boat in the Cayman Islands, where it sat in decay.

2. Jeanette Winterson, "Much Ado About Nothing," *Guardian*, Sept. 29, 2005, www.guardian.co.uk/film/2005/sep/29/1.
3. Patrick T. Murphy, "Dean's Alembic—An Introduction to the Art of Tacita Dean," in Patrick T. Murphy, Sean Rainbird, and Jeremy Millar, *Tacita Dean*, exh. cat. (Institute of Contemporary Art, University of Pennsylvania, 1998), p. 9.
4. Barry Schwabsky, "Cine Qua Non: The Art of Tacita Dean," *Artforum* 37, 7 (Mar. 1999), p. 100.

Rineke Dijkstra, pp. 38–39.

1. Rineke Dijkstra quoting Diane Arbus in Jessica Morgan, ed., *Rineke Dijkstra: Portraits*, exh. cat. (Institute of Contemporary Art, Boston/Hatje Cantz, 2001), p. 8.
2. The Art Institute of Chicago is the only institution with the full series of Dijkstra's *Beach Portraits*. For more on these works, see Carol Ehlers and James Rondeau, *Rineke Dijkstra: Beach Portraits* (Chicago: LaSalle Bank, 2003).

Kendell Geers, p. 40.

1. At the 1993 Venice Biennale, for instance, Geers officially changed his birthdate to "May 1968," recalling the tumultuous strike and student revolt in France.

Helen Mirra, p. 41.

1. Laurie Palmer, "Helen Mirra, Chicago Project Room," *Frieze* 46 (May 1999), p. 97.

Joshua Mosley, pp. 42–43.

1. Of his process, Mosley has remarked, "The noisy way that paper receives the charcoal marks and the challenge of matching values from frame to frame relate to my belief that thoughts from the human mind might be more accurately represented using analog patterns found in natural media." Artist's statment, 2005. Curatorial files, Department of Modern and Contemporary Art.
2. Ibid.

Zarina Bhimji, pp. 44–45.

1. Artist's statement, 2001. Curatorial files, Department of Contemporary Art.
2. Zarina Bhimji, e-mail message to Nora Riccio, Feb. 17, 2009. Curatorial files, Department of Contemporary Art.
3. Ibid.

Charles Ray, pp. 46–47.

1. "Lisa Phillips: Interview with Charles Ray, 4/10/97," *Sculpture: Projects in Münster 1997*, ed. Klaus Klaussman, Kasper König, and Florian Matzner, exh. cat. (Westfälisches Landesmuseum/Gerd Hatje, 1997), p. 334.
2. "Interview by Robert Storr with Charles Ray: Anxious Spaces," *Art in America* 86, 11 (Nov. 1998), p. 104. Around 1996, the artist conceived of another film, *Self-Portrait with Homemade Clothes*, in which he intended to re-create, completely by hand, the clothing he typically wears, including jeans, a flannel shirt, and a khaki jacket.

3. Phillips and Ray (note 1), p. 333.
4. Paul Schimmel, *Charles Ray*, exh. cat. (Museum of Contemporary Art, Los Angeles/Scalo, 1998), p. 89.

Amar Kanwar, pp. 48–49.

1. Quoted in University of Minnesota, "Art and Commitment: A Conversation between the Arts about Their Role in Contemporary Society," http://artandcommitment.umn.edu/beckerkanwar.html#becker.

Sharon Lockhart, pp. 50–51.

1. Sharon Lockhart, interviewed by Scott McDonald in idem, *A Critical Cinema 5: Interviews with Independent Filmmakers* (University of California Press, 2006), p. 316.
2. Ibid., pp. 328, 330.
3. Sharon Lockhart, "Director's Statement," in "NO: 35," *Berlinale: Annual Archive 2004*; downloadable at www.berlinale.de/external/de/filmarchiv/doku_pdf/20042665.pdf.

Eija-Liisa Ahtila, pp. 52–53.

1. "Thinking in Film: Eija-Liisa Ahtila in Conversation with Chrissie Iles," *Parkett* 68 (2003), p. 59.

Salla Tykkä, pp. 54–55.

1. Quoted in *Salla Tykkä: Cave*, exh. cat. (Copenhagen: Statens Museum for Kunst, 2004), p. 7.
2. Ibid, p. 6. For more on Tykkä, see James Rondeau, "Power + Play," in *Salla Tykkä*, exh. cat. (Kunsthalle Bern, 2002), pp. 10–15.

Diana Thater, pp. 56–57.

1. Carol Reese in "Conversation between Carol Reese and Diana Thater," in *Secession: Diana Thater; Delphine*, exh. cat. (Vienna: Secession, 2000), p. 23.
2. Ibid.
3. Ibid.
4. Ibid., p. 24.

Rodney Graham, pp. 58–59.

1. Christopher Miles, "Lost In the Moment," *Art In America* 93, 3 (Mar. 2005), p. 108.
2. Artist's statement, Donald Young Gallery, Chicago, Apr. 2005. Curatorial files, Department of Contemporary Art.
3. Christina Bagatavicius, "Rodney Graham: A Glass of Beer and Other Works," *Parachute Magazine* 122 (Apr.–June, 2006), www.parachute.ca/public/+100/122.htm.

David Hammons, pp. 60–61.

1. David Hammons, interviewed by Maurice Berger in "Speaking Out: Some Distance to Go," *Art In America* 78, 9 (Sept. 1990), p. 80.

Nan Goldin, pp. 62–63.

1. For more on the history of the slide projector in contemporary art, see M. Darsie Alexander, *Slide Show: Projected Images in Contemporary Art*, exh. cat. (Baltimore Museum of Art/Pennsylvania State University Press, 2005).

2. For a history of snapshot photography, see Douglas R. Nickel, *Snapshots: The Photography of Everyday Life, 1888 to the Present*, exh. cat. (San Francisco Museum of Modern Art, 1998). For critical analysis of the restrictive cultural conventions of snapshots, see Pierre Bourdieu, *Photography: A Middle-Brow Art*, trans. Shaun Whiteside (1965; repr. Stanford University Press, 1990).
3. As the slide show progresses, Goldin and her subjects appear, coming to view on screen and receding again in a cinematic mimicry of the nonlinear fashion of memories.

Gordon Matta-Clark, pp. 64–65.
1. For more on Anarchitecture, see Judith Russi Kirshner, "The Idea of Community in the Work of Gordon Matta-Clark," in *Gordon Matta-Clark* (Phaidon, 2003), pp. 148–60.
2. "Live Cinema: Gordon Matta-Clark," www.philamuseum.org/exhibitions/collection/236.html.
3. Andy Grundberg, "Splitting: A Chronicle of a House Divided," *New York Times*, Dec. 14, 1990.

Vito Acconci, John Baldessari, and Dara Birnbaum, pp. 66–67.
1. Purchased in 2006 in an effort to fill gaps in the Art Institute's early video holdings, these works were selcted for their particular importance to the histories of Conceptual and performance art, appropriation, and media critique. Due to restrictions in the Video Data Bank's distribution policies, the museum was not able to obtain master copies and thus could not officially accession these works. Insead, it created the New Media Study Collection, which allows them to be exhibited and made available for study but not reproduced or lent to other institutions.

Pierre Huyghe, pp. 68–69.
1. Quoted in Noel Daniel, ed., *Broken Screen: 26 Conversations with Doug Aitken; Expanding the Image; Breaking the Narrative* (D.A.P./Thames and Hudson, 2006), p. 177.

Darren Almond, pp. 70–71.
1. Martin Herbert, *Darren Almond*, exh. cat. (Kunsthalle Zurich, 2001), p. 22.
2. Ibid., p. 26.

Doug Aitken, pp. 72–75.
1. "Amanda Sharp in Conversation with Doug Aitken," in Daniel Birnbaum, Amanda Sharp, and Jörg Heiser, *Doug Aitken* (Phaidon, 2001), p. 8.
2. Martin Heidegger, "The Thing," in *Poetry, Language, Thought* (Perennial Classics, 2001), p. 164.
3. Quoted in Jeffrey Kastner, "No Label, No Boundaries: An Artist of the Moment," *New York Times*, Oct. 6, 2002, p. 35.

Vanessa Beecroft, p. 76.
1. Quoted in Robert Knafo, "Economy of Desire," *New York Times*, Sept. 9, 2001, p. 72.

Jeanne Dunning, p. 77.
1. For more on Dunning, including a selective survey of her photographs and videos, see Heidi Zuckerman Jacobson, *Jeanne Dunning: Study after Untitled*, exh.

cat. (University of California-Berkeley Art Museum/Pacific Film Archive, 2006).

Sam Taylor-Wood, p. 79.
1. Quoted in Germano Celant, ed., *Sam Taylor-Wood*, exh. cat. (Fondazione Prada, 1999), p. 270.

Isaac Julien and Javier De Frutos, pp. 82–83.
1. Julien has written extensively on film, race, and queer theory, including coauthoring several publications with Kobena Mercer; for these works, see Amada Cruz, David Deitcher, and David Frankel, *The Film Art of Isaac Julien*, exh. cat. (Center for Curatorial Studies, Bard College, 2000).
2. CinemaScope is a widescreen film format used during the 1950s and 1960s. Unlike the conventional 1.37:1 aspect ratio, CinemaScope allowed for the projection of films in a 2.66:1 aspect ratio, making them nearly twice as wide as traditional films.
3. Museum of Contemporary Art, Chicago, *Isaac Julien*, exh. brochure (2001), n.pag.
4. "The Long Road: Isaac Julien in Conversation with B. Ruby Rich," *ArtJournal* 61, 2 (Summer 2002), p. 59.
5. Ibid. p. 64.
6. Notably, *Lonesome Cowboys* features random, fragmented elements of dance throughout.
7. Julien and Rich (note 4), p. 55.

Hirsch Perlman, pp. 84–85.
1. Press release, Hirsch Perlman exhibition at Donald Young Gallery, Chicago, Jan. 25, 2002. Curatorial files, Department of Contemporary Art.

Janine Antoni, pp. 86–87.
1. Another work that embodies these ideas is the Art Institute's photograph *Mortar and Pestle* (1999), which shows the artist's tongue touching her husband's eyeball. Antoni is trying to "taste" someone else's vision.
2. Susan Sollins, "Loss and Desire: Janine Antoni," in idem, *Art:21: Art in the Twenty-First Century* (Harry N. Abrams, 2003), p. 81.
3. Janine Antoni, "'Touch' and 'Moor,'" in *Art:21: Art in the Twenty-First Century*, www.pbs.org/art21/artists/antoni/clip1.html.
4. Quoted in Andrea Inselmann, *Im/Balance: Janine Antoni's "Touch" and Patty Chang's "Losing Ground,"* exh. brochure (Robert F. Johnson Museum of Art, Cornell University, 2003).

Anri Sala, pp. 88–89.
1. These themes are also prevalent in *Now I See* (2004), which the Art Institute commissioned on the occasion of Sala's *focus* exhibition the same year.

Jenny Holzer, pp. 90–91.
1. The Art Institute's Department of Prints and Drawings owns twenty-nine of Holzer's *Inflammatory Essays* posters.
2. John Yau and Shelley Jackson, "An Interview with Jenny Holzer," www.poetryfoundation.org/features/feature.onpoetry.html?id=178606.

Steve McQueen, pp. 92–97.
1. The mission of McQueen's protagonists seems to have little to do with Marley's Rastafarian anthem. Yet the sense of progress and unity that pervades both Marley's song and McQueen's film links the very different work by these two artists with roots in the West Indies.
2. "Steve McQueen in Conversation with Gerald Matt," in *Steve McQueen*, exh. cat. (Kunsthalle Wien, 2001), n.pag.
3. Jerry Saltz, "Mourning Glory," *Village Voice*, Feb. 1, 2005.
4. These contrasting scenes bring to mind the adage "The sun never sets on the British empire." The film also makes clear reference to Joseph Conrad's novella *Heart of Darkness* (1899), in which the protagonist Marlow, writing from a sailboat docked in Gravesend, recounts his journey up the Congo River and the brutality of the Belgian colonial ivory trade he witnessed there.

Andrea Fraser, pp. 98–99.
1. Yilmaz Dziewior, *Andrea Fraser: Works, 1984 to 2003*, exh. cat. (Dumont/D.A.P., 2003), p. 13. For more on Fraser, see Yilmaz Dziewior and Andrea Fraser, *Andrea Fraser* (DuMont, 2002); and Andrea Fraser and Alexander Alberro, *Museum Highlights: The Writings of Andrea Fraser* (MIT Press, 2007).

Fischli & Weiss, pp. 100–01.
1. Quoted in Jorg Heiser, "The Odd Couple" *Frieze* 102 (Oct. 2006), p. 202.

A K Dolven, pp. 102–03.
1. Andrea Schlieker, "Moving Mountain: Time and Transformation in the Work of A K Dolven," in idem, *A K Dolven: Moving Mountain*, exh. cat. (Bergen Kunsthall, 2004), p. 51.
2. A K Dolven, interviewed by Ele Carpenter in *It Could Happen to You: A K Dolven* (Film and Video Umbrella, 2001), n.pag.

Elad Lassry, pp. 104–05.
1. Lassry discussed Goldstein's work as an inspiration for *Zebra and Woman* in an e-mail exchange with his former teacher, artist Sharon Lockhart (see pp. 50–51 in this publication); Stuart Bailey, ed., *Texts and Images from the USC Roski School of Fine Arts, MFA, 2007* (USC Roski School of Fine Arts, 2007), p. 35.
2. *Both Zebra and Woman* and *Untitled (Agon)* are unusual in that they were not only shot, but are also projected, in the Super 16mm format, which is an economical and practical method of shooting but not typically used for viewing. This decision enabled Lassry to achieve the quaint intimacy of traditional 16mm with the wider visual field associated with 35mm cinema.
3. Lassry has remarked that Mitchell's appeal resides both in her recognizability—she starred, for instance, in the gay cult film *High Art* (1998), loosely based on the life of Nan Goldin (see pp. 62–63)—and in a more generic quality that recalls the blonde beauties of Alfred Hitchcock's films. Elad Lassry, conversation with Lisa Dorin, Feb. 11, 2008.